THE
WATERCOLOUR
ARTIST'S PALETTE

THE
WATERCOLOUR
ARTIST'S PALETTE

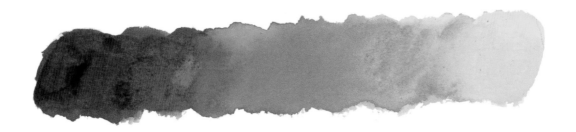

Choosing and Mixing Your Paints

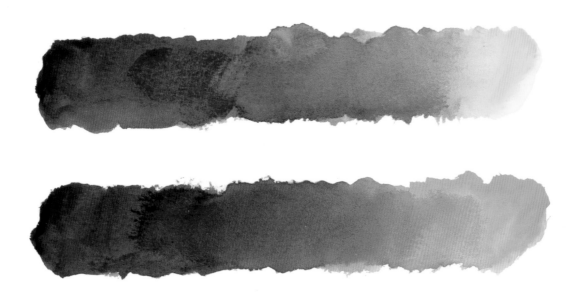

Tom Robb

AURUM PRESS

For Duncan Alistair Grant

First published 1998 by Aurum Press Limited,
25 Bedford Avenue, London WC1B 3AT

A catalogue record for this book is available from the
British Library.

ISBN 1 85410 553 1

10 9 8 7 6 5 4 3 2 1
2002 2001 2000 1999 1998

Printed in Hong Kong / China by
South China Printing Co. (1988) Ltd

CONTENTS

Introduction

Colour is the heart of painting, and being able to mix the exact colour you want to put onto the paper is one of the greatest joys any artist can discover.

Without that skill, you can master all aspects of watercolour and yet still be disappointed and frustrated by failure, over and over again.

So it is worthwhile taking a little time and trouble to find out how colours behave under different circumstances, what pigments work well together and how to set about making an essential colour library for your own use.

What are pigments?

All pigments were originally made by dissolving or grinding up natural materials such as minerals, plants or insects. Today, many natural pigments have been replaced by synthetic substances made in the laboratory. The first synthetic pigments were produced as substitutes for natural ingredients which were of varying quality, which faded quickly or which were difficult to obtain or were toxic; but over the years the range has been widened to include many new colours which are simply unobtainable from natural sources.

How watercolours are made

Watercolours are pure pigments mixed with gum to act as a binder and glycerin to keep the paint moist. They are sold in two forms, as dry half-pans or full pans, or in tubes. Tube paints are already mixed with a little distilled water to make them slightly liquid, and in the studio I prefer them because paint almost straight from the tube gives a very intense colour. Outdoors, of course, boxes are much more convenient as they can be slipped into a pocket. You can buy boxes with a set of pans, or empty boxes which you can fill with your preferred colours.

How pigments behave

Watercolours give clear, transparent washes that cannot be achieved with any other medium. However, there are wide variations in how individual pigments behave in use, which can affect the success of your mixes to a greater or lesser degree.

A major factor in determining their behaviour is whether the pigments are classed as granular or stains. Granular pigments clump together even when dissolved, while staining or dyeing pigments saturate the water much more evenly.

The differences between granular pigments and stains have implications which are discussed more fully in the separate

sections. A list of the most important colours and their classifications is given on page 29, but today so many colours are mixed from various sources by different manufacturers, that it is better to look at the maker's paint chart to be sure what you are buying.

The type of paper (except for tinted papers, of course) does not affect the colour as such, but a very rough paper will hold more paint in the hollows and will give any pigment more texture.

The summary of the book's contents which follows will help you use it to the best advantage.

PART ONE, Colours of the Palette, is a personal selection from the spectrum, detailing some of the characteristics useful in creating mixes. These are colours I use over and over again, and which I feel give the widest possible scope for creating new and exciting mixes.

PART TWO, Problems and Possibilities, explores the queries I get most frequently from my students and correspondents, as well as notes on some of the difficulties that all artists, no matter how experienced, wrestle with from time to time – how colours behave when working wet on wet, a storm-shadowed sky, a tinted paper, or the need to lay clear washes in many layers.

PART THREE, Colour Codes, is the core of the book, with a selection of the mixes I find most useful. In the first section, *Two-colour blends,* the examples have been painted in both light and dark washes, so that the subtleties of modulating colours in a variety of intensities can be explored. The second section, *Variations on a theme,* shows how strikingly a mix can change when you choose one yellow, for example, instead of another.

And finally, there is the **APPENDIX,** where I show you how to make your own Colour Codes, because nothing will give you as much information as painting a set for your-self, as well as exploring why I think Colour Codes are so important, both in the studio and outdoors.

While putting this book together, I have been on a voyage of discovery, as I tried to see how many subtle variations on a theme I could conjure up, and explored new colour combinations. The result is that my own colour reference library looks like increasing far beyond expectations, and there will be new kinds of pigments to try out... I can only hope that you too will enjoy this journey and that it will lead you to more exciting and successful painting.

Tom Robb

PART ONE: Colours of the Palette

Yellows

Yellow's original purpose was to imitate gold, and it was used as a substitute in all but the most expensive medieval paintings. Modern yellows are made from a variety of synthetic dyes. It is difficult to retain their lightness and clarity in mixes, so remember to begin with them and add other colours.

1. Lemon Yellow

A bright, transparent colour with a leaning towards green.

2. Chrome Yellow

Stronger, with good covering power, but it can darken gradually, even going grey, so in mixes I usually choose to use . . .

3. Cadmium Yellow Pale

instead, a softer colour that stays light.

4. Cadmium Yellow Medium

Bright and clear, with a good bit of orange. Good for sunny highlights.

1

2

3

5. Aureolin

Sometimes called Cobalt Yellow; it's an asset because of its clarity, which remains even in washes; I find it a little more reliable than the previous colour.

6. Cadmium Yellow Deep

Quite orange, with very good covering power; a good, strong yellow for brilliance and punch.

7. Indian Yellow

Slightly lighter deep yellow, with very little red. Perfect for autumn shadows.

8. Gamboge

Once a mineral and plant mix, now made chemically. It may fade in strong light but the modern mixes add warmth and depth to paler yellows, while remaining brighter than Yellow Ochre. A variable blend, there are often complaints that such vague names inherited from the past should be eliminated from the artist's range, but I find a good version is a welcome addition to the palette. Look at more than one make to find a mix which suits your work.

5 6 7 8

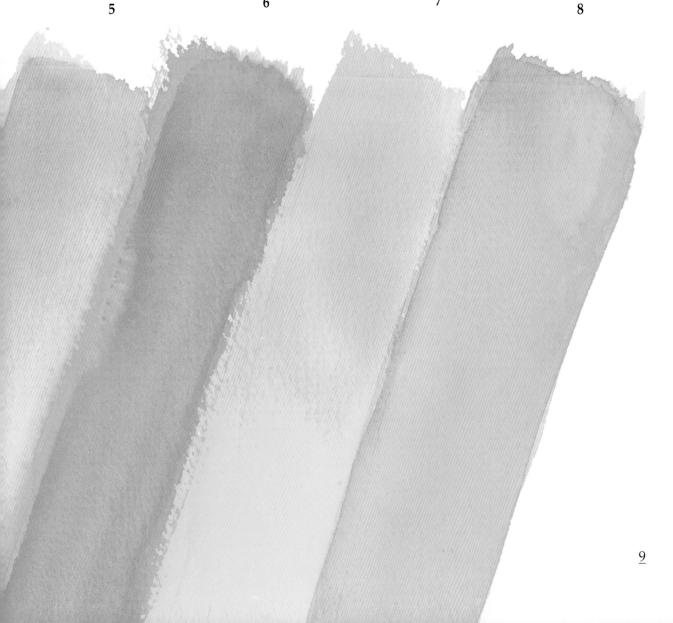

Reds

In the past, reds have been sourced from roots, vegetables, berries, flowers, resins, insects, clays, etc. But it was always a difficult colour to make – often fugitive, and sometimes extremely toxic.

1. Cadmium Red

An important, but toxic, mineral red, heated to achieve varied levels of light and deep. It will not bleed easily into other colours, it is absolutely lightfast, and quite expensive.

2. Rose Madder

The original dye of the madder root from Asia, some 3,000 years old, now produced synthetically. It can vary according to the manufacturer. Fades in a light wash.

3. Venetian Red

An earth colour with a dark brown tint. Lightfast, it will produce a slightly grey tinge in very light washes.

4. Vermillion

Based on mercuric sulfide, this must be

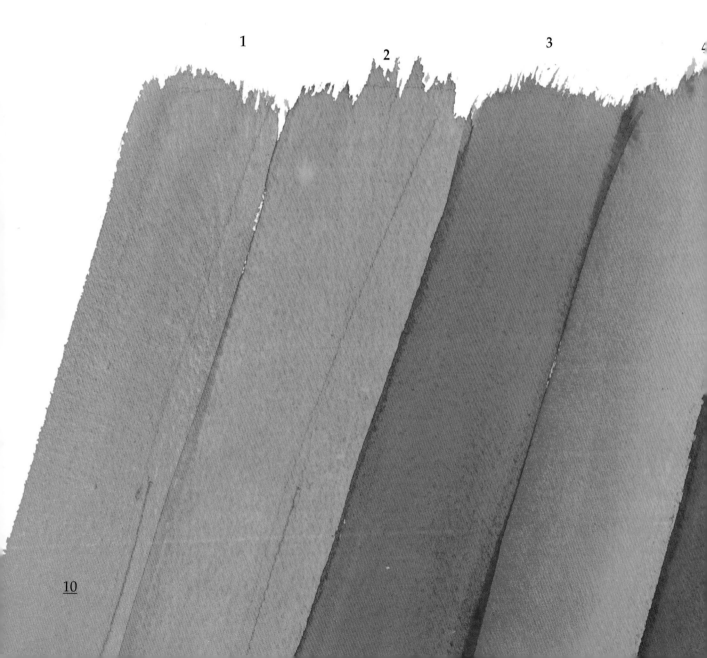

1 2 3 4

handled with care. It darkens on exposure to light. As a heavy pigment it tends to sink into pools and gives texture to the wash.

5. Mars Red

Also an iron oxide, synthesized to produce a soft brick colour. A mixture, it varies according to the formula used, and some can be quite brown. Generally very lightfast.

6. Indian Red

A neutral red-brown, with an unusual cold cast which makes it a useful addition to the palette. Absolutely lightfast.

7. Crimson Lake

Crimson Lake was originally used to describe a clear violet. Today it is a soft, deep red with some very subtle undertones. I use it a great deal for interior shadows.

8. Alizarin Crimson

Since the 1920s it has replaced most of the old lakes and madders. Though essential, its power must be used sparingly.

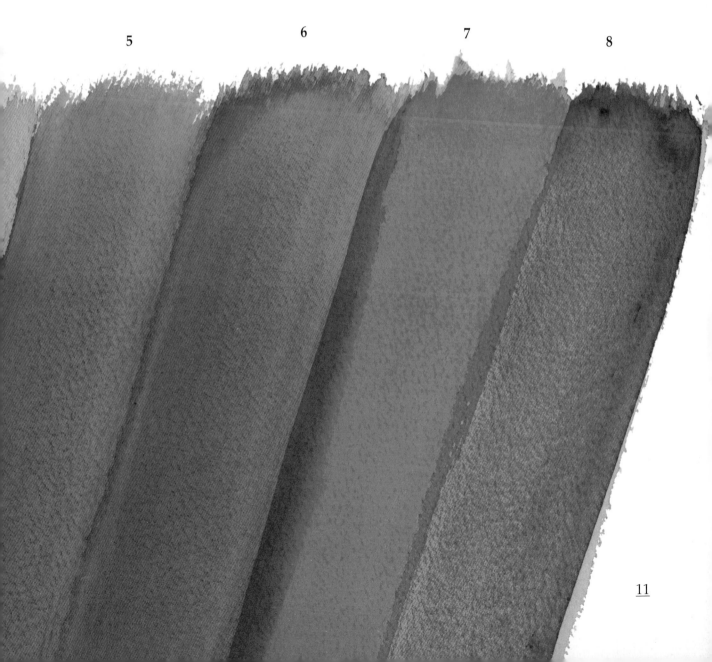

5 6 7 8

Violets

Marvellous colours, full of richness and light. The deep, most brilliant violets cannot be mixed from other colours.

1. Magenta

The standard red in four-colour printing. For artists, a bright reddish violet, giving clear washes when diluted. When made with quinacridone, it is permanent.

2. Cobalt Violet

In use since the 1800s, and first made with arsenic, this brilliant but delicate colour cannot be mixed, so with all its faults (gummy, hard to use) it is irreplaceable.

3. Manganese Violet

A toxic colour used in cosmetics as well as paint; it dries out in tubes and is available only in pans. Based on manganese dioxide, it is slightly unsaturated and granular, giving a lovely rich texture.

4. Dioxazine Purple

Available in two versions, one distinctly red, the other more blue. Expensive, but

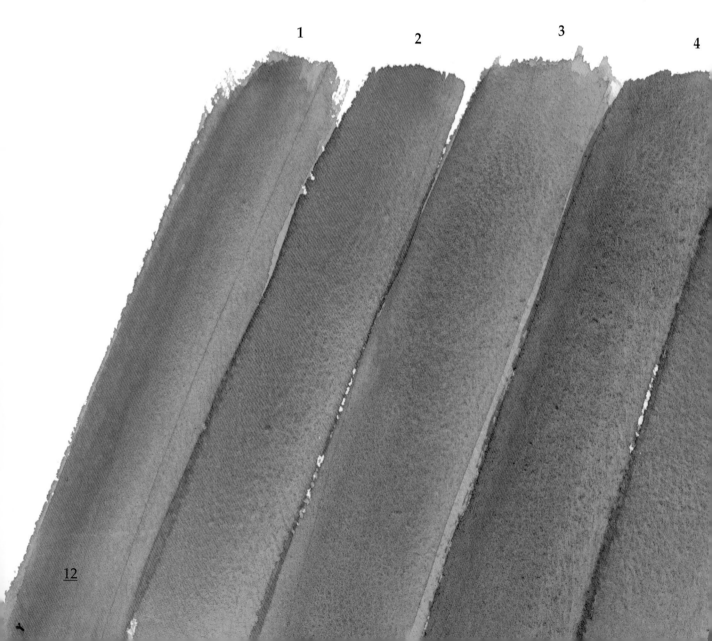

1 2 3 4

the colour is very strong, so use sparingly. It fades quickly; protect work from light.

5. Mauve

Originally a coal-tar dye, now a name carelessly used for a whole range of violets. Neither reliable nor lightfast, but essential in flower painting.

6. Purple Madder

Redder than mauve, with quite a lot of brown, this mixture stays a clean colour in a light wash. Perfect for winter shadows.

7. Thioindigo Violet

Obviously related to indigo, this is often described as red rather than violet. A lovely, dark, reddish purple pigment made since the 1950s.

8. Ultramarine Violet

A granular colour, beautifully transparent, for lighter, smooth washes. It can enhance the texture of the paper, and yet lifts easily. To be used generously for its variations in tone, especially when worked wet on wet.

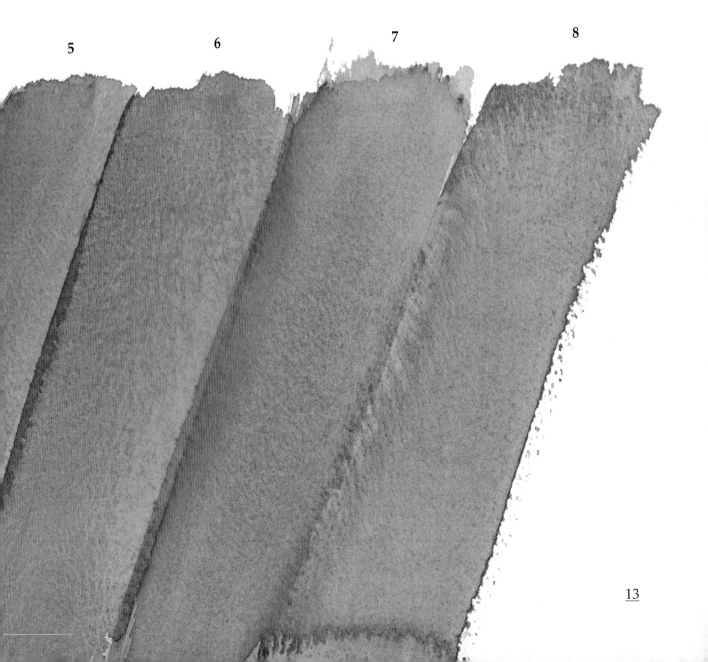

5 6 7 8

Blues

Used extensively in all the decorative arts as well as in painting, blues were originally made from plants (indigo and woad) and stones (lapis lazuli).

1. Cerulean Blue

A delicate greeny blue, often, as its name suggests, used for skies. Relatively easy to lift, with some opacity, and essential for the landscape artist.

2. Cobalt Blue

First used about 2,000BC in Persian glass and pottery, Cobalt is the clearest blue, but not as powerful as Ultramarine. Lightfast, its granular texture enhances any wash.

3. Ultramarine

This was the original replacement for lapis lazuli, developed c. 1828. If you can only have one blue this is the one. Valued for its transparency, and yet good covering power, and its clean washes. Incidentally, it is the same blue still used in laundries to whiten linen!

4. Prussian Blue

Created in 18th-century Prussia; use carefully or it will flood every inch of the paper. Its unique sharpness is distinct.

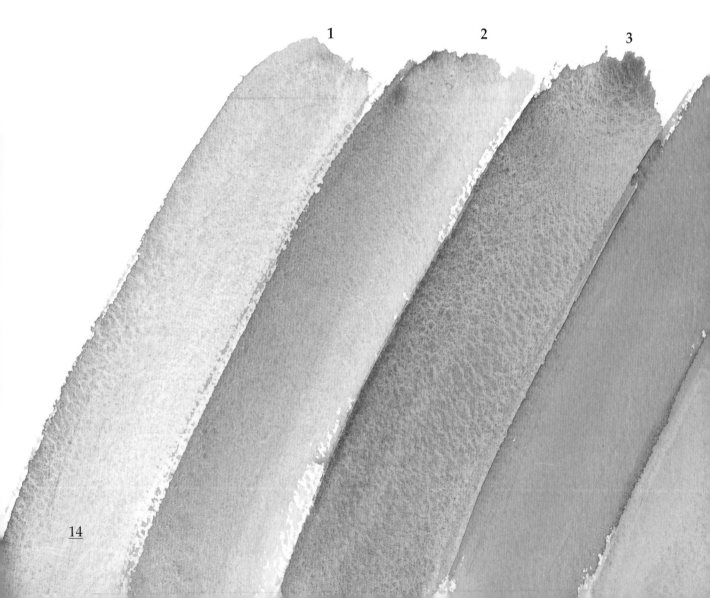

1 2 3

5. Manganese Blue

Slightly green, with its own character, but because of its inert quality it will not bleed or mix easily, tending to separate on the paper, which can create beautifully textured washes. It is lightfast and easy to lift, so it makes good background washes.

6. Indigo

Genuine indigo is one of the most famous plant colours in the world, and modern substitutes are not very satisfactory or lightfast. The dark grey tone of the genuine pigment is unique among the blues, and irreplaceable for night skies.

7. Phthalo Blue

A modern compound prized by many artists because of its vibrant clean, blue-green tone and its transparency. I like it in its lighter tone shown below.

8. Turquoise

A made-up name for almost any mixture of blue and green, and like the natural stone itself it can be more green or more blue. An important colour for seascapes, in particular for waves and the shadows in water, but useful also for flowers.

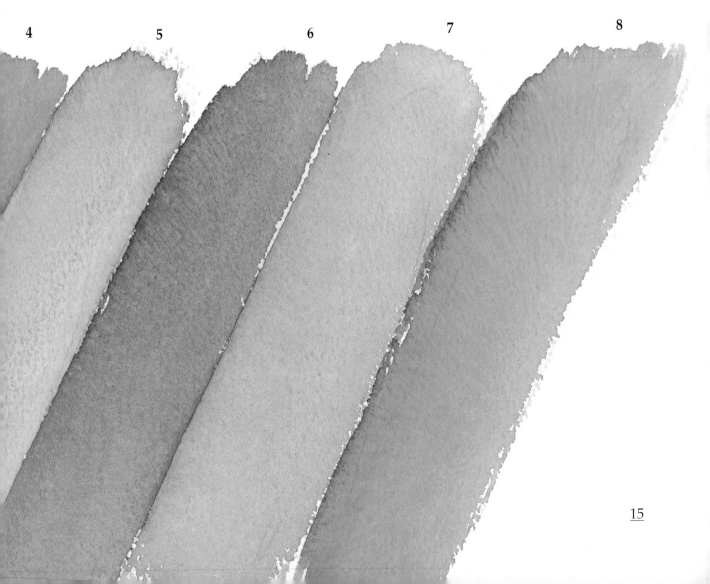

4 5 6 7 8

Greens

Copper is the thread running through the green palette – malachite, known to us as a semi-precious stone, was used by Van Gogh, and is a copper carbonate. Many well-known green colours are mixes which vary greatly.

1. Viridian

A true pigment, the most versatile of the greens, bright, clean, and transparent. It mixes well with all blues or yellows, and its strength means that it shows up beautifully in light washes and glazes. The granular base makes it easy to lift.

2. Phthalo Green

A new green (1990s) available in both blue and yellow shades; all the phthalos are clear, very transparent, and absolutely lightfast. As stains, they will not lift easily.

3. Hooker's Green

Supposedly named for an artist, it is a variation on a dullish green and will fade, stain, or not, according to its content.

4. Sap Green

Originally made from buckthorn berries, this is another wildly varying colour, but

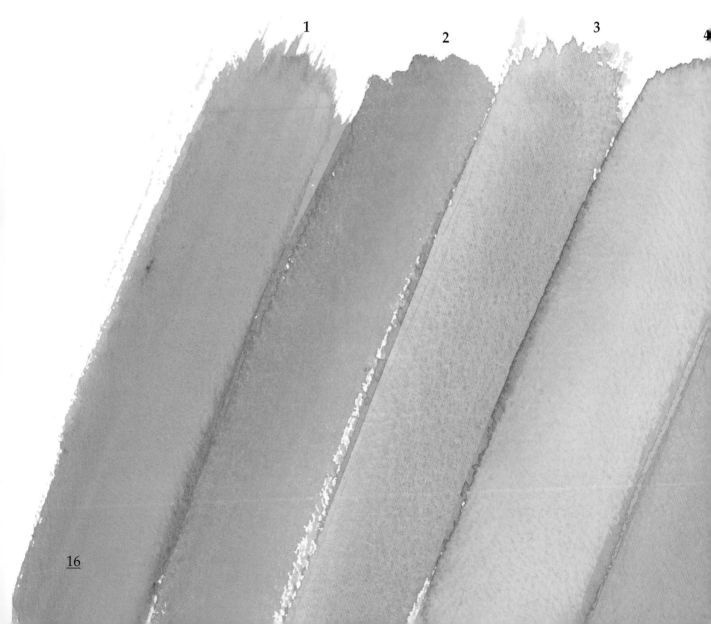

mostly a kind of crushed-leaf hue, more yellow than blue.

5. Chromium Green

A fine green, yellow in cast, good in a mix to soften or neutralize other colours.

6. Cobalt Green

Some Cobalt Greens are mixes. True Cobalt is produced in a wide range, but I prefer this one, called Cobalt Green Pale. It gives a bright bluey-green distinct from the other colours, and lifts well.

7. Emerald Green

Originally a highly poisonous pigment made from copper and arsenic, which has not been used since the 1960s. Today, it means any mixture which gives the colour we associate with an emerald stone.

8. Terra Verte, also known as Green Earth

The true pigment is a subtle earth colour of soft olive, used in frescos for shadows and underpainting. Check the ingredients; if strengthened with dye to deepen the colour, it may not be easy to lift.

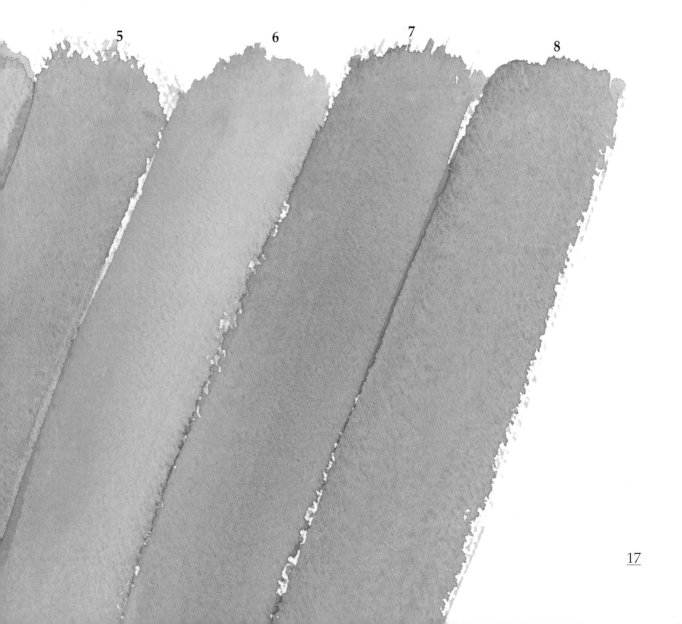

Browns

The original browns were mainly Bistre, made from boiling wood soot, and one made from the liquorice plant. Today the range has been extended into browny-reds and blacks.

1. Yellow Ochre

This is the most important earth colour, a soft, golden brown which adds warmth and depth to almost any painting. Absolutely essential, irreplaceable.

2. Raw Sienna

An iron oxide. Check the ingredients because many brands are dark Yellow Ochres in disguise. True Raw Sienna is transparent, absolutely lightfast and smooth. Being a granular clay, it will not bleed, but lifts easily.

3. Burnt Sienna

The warning above also applies to Burnt Sienna. The true pigment is a lovely colour, rich and smooth, even in thin washes. In mixes it behaves like orange rather than brown.

4. Van Dyke Brown

A deep colour, once based on coal or wood.

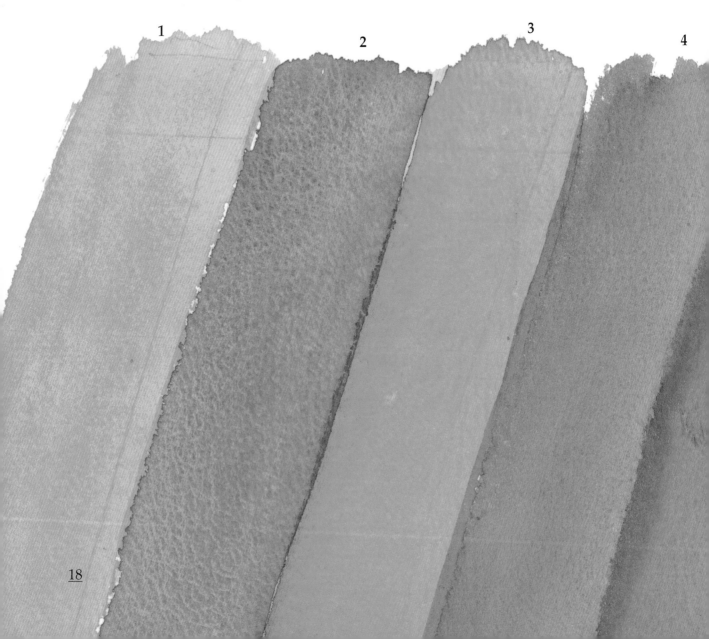

It fades to a dull, cold grey-brown after a comparatively short time. New ingredients are now used, and it is a useful cool brown hue.

5. Sepia

Originally a blackish brown made from cuttlefish or squid ink, and often used for drawing ink. Modern versions may tend towards red, but it is still a useful colour.

6. Brown Madder

Another mix, although once a natural plant dye, Brown Madder often contains Alizarin Crimson. It fades easily, and being a stain, it is quite difficult to lift.

7. Raw Umber

A lovely earth pigment with a little green in its makeup. Raw Umber is transparent, light and granular. It doesn't mix easily but I use it for its unmatchable colour.

8. Burnt Umber

Roasted Umber gives a soft neutral brown. Burnt further it becomes reddish. Mixed with Ultramarine, it makes a warm black which I prefer to Lamp Black in light washes.

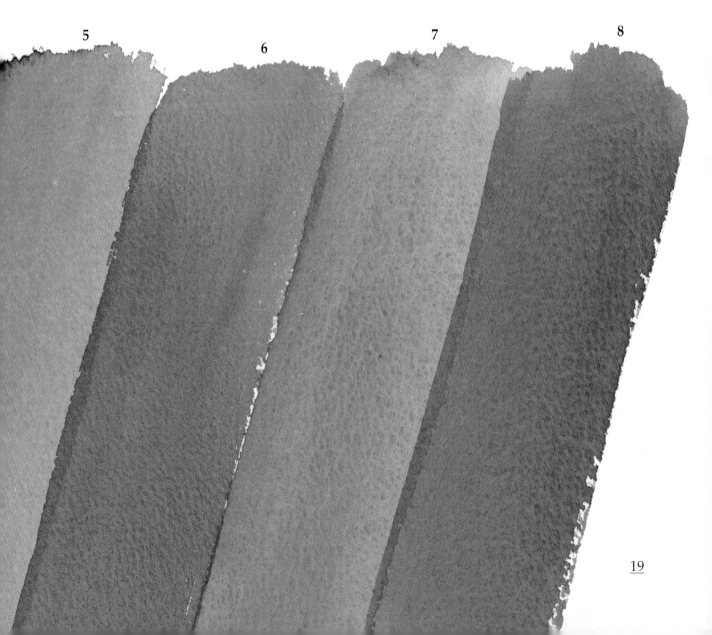

5 6 7 8

Blacks and Whites

Greys and blacks are mostly made from charred wood or bone; there are no true whites in watercolour, but manufacturers have treated white pigments to make them soluble in water. Most artists keep these to add highlights or to increase the opacity of a colour.

1. Ivory Black

Once made from ivory clippings, it is a rich, velvety black with browny undertones. When ivory became unobtainable animal bones were substituted. With good covering power, it is completely lightfast.

2. Lamp Black

A cool black, with blue undertones, made from soot. This creates a most unusual quality – the pigment is so light and powdery that it separates easily from water leaving a slight ring around the area. More opaque than Ivory Black, it has been used for drawing inks, both Chinese and Western.

3. Payne's Grey

A mixture which is convenient for darkening the hue of a colour and yet retaining a hint of the original. It does vary, so try out different makes.

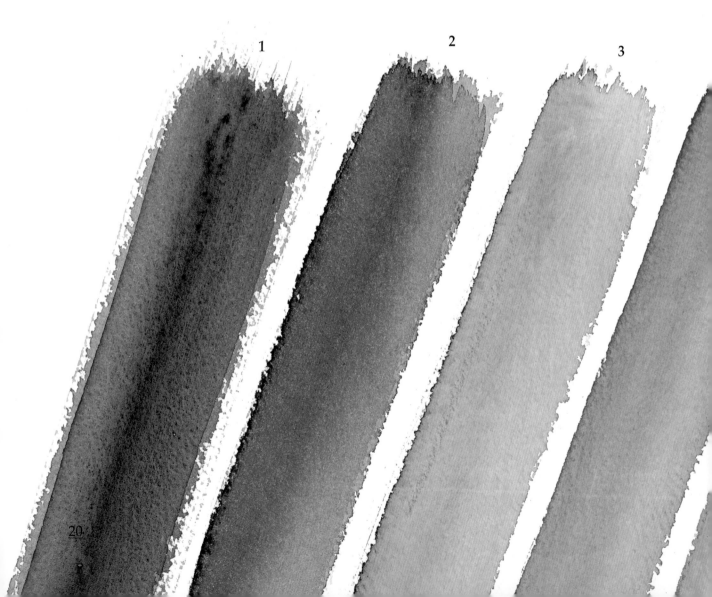

1 2 3

4. Neutral Tint

The name of a wide variety of mixes which generally make a quiet, semi-opaque black. An alternative to Lamp or Ivory Black because it will have a blue or brown cast to it, which makes effective shadows with a hint of colour.

5 and 6. Chinese or Zinc White

Made from a zinc oxide, dating from the mid-18th century, when it was developed as an alternative to poisonous Lead White. When Chinese White is mixed with other colours it makes pale washes that are richer and yet more delicate than a water-only wash.

7 and 8. Titanium White

A newer pigment developed in the 1920s. The pure Titanium is a cold white, very resistant to fading or yellowing, with good covering power.

As the subtle differences of these last two whites will not show when printed, I have mixed them with varying amounts of neutral tint so that you can compare their qualities.

4 5 6 7 8

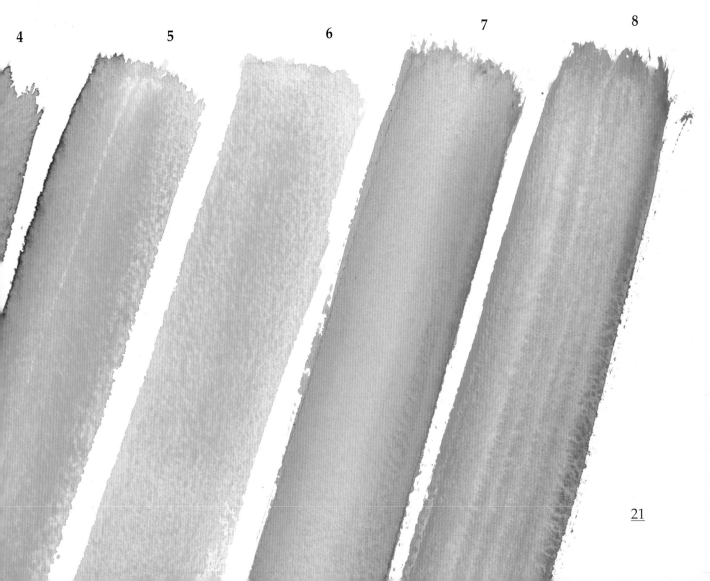

Choosing a Palette

Some beginners' books on painting state confidently that new artists can buy just three tubes or pans of the primary colours and mix any colour they want out of these. In practice, it is far from easy and in some cases quite impossible.

Pigments are made from many substances: metal oxides, organic materials and synthetic chemicals. They don't necessarily blend or mix equally well with each other. For example, Cadmium Red is less successful mixing with blue than it is with yellow, it makes a good, strong orange, but a poor, muddy purple; while Alizarin Crimson can be mixed to a better purple than Cadmium Red, but a less successful orange.

Some pure pigments simply cannot be matched in any mix; one is Viridian. You can blend Ultramarine or Prussian Blue with Cadmium Yellow, but it will be a poor second to the true cold, clean colour, which is an oxide of chromium.

Even a simple earth colour like Yellow Ochre is in practice very hard to match, and more experienced artists soon realize that it makes sense to regard some colours – especially the mauves, the browns, Viridian and many other greens – as a fundamental requirement, just as essential as the primaries (red, blue and yellow). You would need to do some very careful mixing to achieve a good result using only two colours, which gives the clearest colour, while three colours become increasingly muddy, and a four-colour mix would be almost certain to fail. Adding so much preliminary work before you start seems to me to be an excess of purity.

Modern manufacturers set out to produce a wide range which can be used confidently by the painter. Instead of having just one yellow, you really need three, a cool greenish Lemon as well as a warm Cadmium Yellow and of course the earthy Yellow Ochre.

A similar range should be chosen for blues; the relatively neutral Ultramarine is slightly red, so you will also need cooler Prussian Blue, which has a strong green cast. The delicate Cerulean may seem just a light wash, but in practice an Ultramarine or Cobalt will not give the same unique, slatey hue.

The palette you choose will also depend on your preferred subject matter – an artist who concentrates on landscape will enjoy having as many greens and blues as possible, while a flower painter will look for a variety of subtle petal colours.

Good watercolour ranges will have about 80 colours, most being pure pigments but

almost always including some mixed colours which are named individually by the manufacturer, and which may be called something different in another range.

Try out various manufacturers' products to find a brand that suits your brushwork and your style of handling paint, but continue to experiment with other brands, too. Although most of the top manufacturers produce first-class products, the lightfast qualities and covering capacity do vary, and they are constantly bringing new ideas and new formulae to the market.

For the precise colourist:

All colours are made in batches, which may vary slightly from one to another. This applies to pigments just as much as it does to wallpaper or fabrics. If you involved in a large painting and you are particularly anxious that you have exactly the same colours throughout the work, then make sure you have enough paint before you begin.

Minimum Suggested Palette:

Lemon Yellow

Cadmium Yellow

Yellow Ochre

Cadmium Red

Alizarin Crimson

Burnt Umber

Viridian

Ultramarine

Prussian Blue

Cerulean Blue

Mauve

Ivory Black

and a Chinese White for highlights.

Extend this by adding:

Indian or Venetian Red

Raw Umber

Raw Sienna

Turquoise Blue

Cobalt Blue

Dioxazine Violet

Payne's Grey

Titanium White.

And then you can pick and choose according to your personal taste. I would recommend Hooker's Green, Sap Green, Cadmium Yellow Deep, Terra Verte or Olive Green, True Indigo, Purple Madder, the new Bismuth Yellow, Lamp Black and Neutral Tint.

Colour confusion

The same names are often used for a wide variety of mixtures. These may be specific to a particular manufacturer, or they may be traditional pigments which have been altered by substituting synthetic constituents for the original ingredients.

Brown Madder is just such a name, once a plant dye, but nowadays a somewhat arbitrary mix used by the colourmen to fill a perceived gap in their particular range. Look at several colour charts before you choose, to find the particular soft brown-red you will find most useful.

Before you decide that is taking too much trouble, just look at the variety of colours below, all of which are called Brown Madder in their respective manufacturers' catalogues.

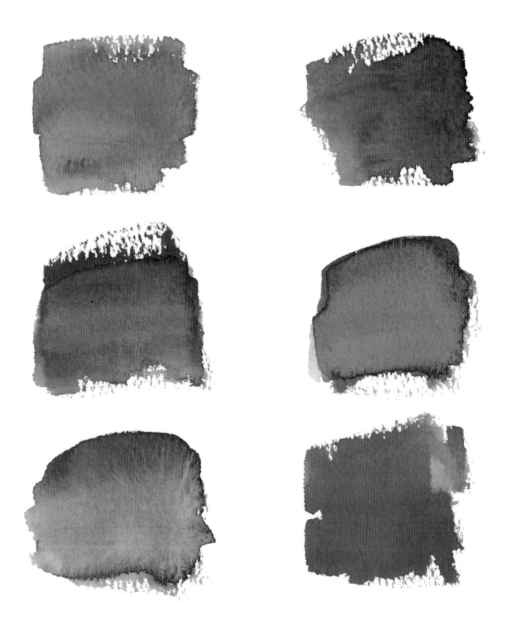

Hooker's Green was a colour supposedly popular with an artist called Mr Hooker, who chose to mix Prussian Blue and Gamboge. Today all the examples below are called Hooker's Green, but their ingredients differ. Sometimes you will see a specific number used by a manufacturer which will at least mean that when you buy more of their Hooker's Green 12 or Hooker's Green 113, it will be the same mix.

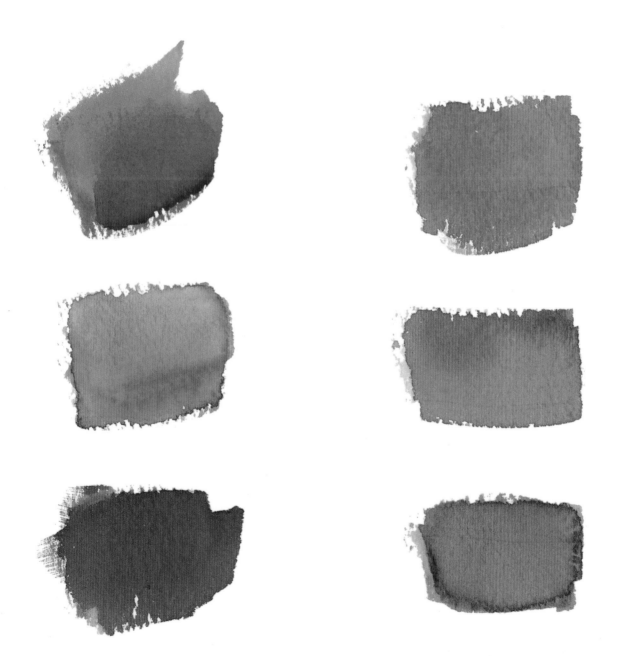

PART TWO: Problems and Possibilities

This section illustrates how an understanding of the subtleties of different pigments can help you to achieve the result you want.

Bleeding

This brings unique effects with great potential, but many artists do not realize that colours vary widely in how much and how quickly they bleed, and how easily the leaching can be controlled.

Dyes which stain are quickly absorbed into neighbouring areas, while the earth colours, basically coloured clays, are much less likely to run. Think of putting a big handful of sand into a bowl of water; the sand drops to the bottom, leaving the water clear, while just one drop of ink will instantly flood all the water with its hue.

This can become especially important for wet on wet painting, as you discover that

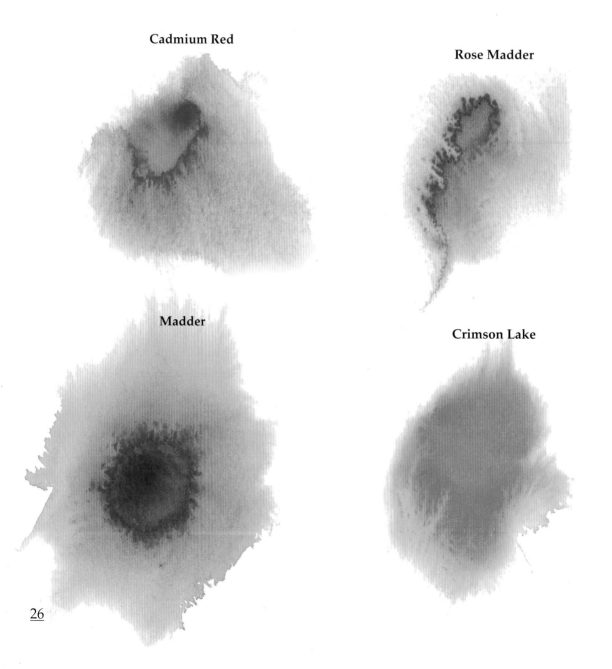

Cadmium Red

Rose Madder

Madder

Crimson Lake

simply adding more water to your brush will not automatically flood your paper to the same degree. You may also need to vary the amount of pigment; a good brushful of Yellow Ochre or Lemon Yellow will only spread a little, while a single stroke with Prussian Blue can run across a whole page.

The examples below are various colours, both mixtures and single pigments, which illustrate different reactions. Some are contained and stay well within the original circle, others spread immediately as far as the water will carry them, while a few leave fascinating results – an aura of darker colour, which could almost be used as an outline, or a waved effect like rippled silk.

Try out colours on a single sheet of dampened paper, putting down a central blob and giving them plenty of room to flood out; later add the name of each one.

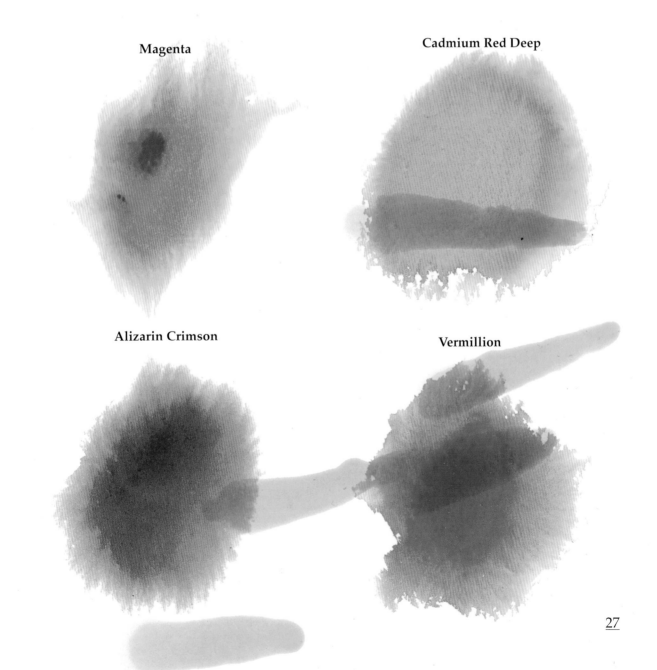

Magenta

Cadmium Red Deep

Alizarin Crimson

Vermillion

Lifting

This quality is important if you need to lift areas of wash for clouds, sails, highlights etc. With an easily removed pigment you can wash in the background without having to work carefully around white shapes. Natural earth colours which are obtained from clay can be wiped out very easily, to leave a seemingly untouched paper. This is the result of their granular consistency, making small clumps which stay on the surface and are easy to remove.

Other colours will permeate the paper and, in effect, stain the fabric; these are almost impossible to lift. They always leave a film of colour, even if you scrub and scrub.

Stains are not confined to chemicals; vegetable dyes can be just as persistent – try taking yellow onion stains out of a shirt!

Lamp Black, for example, is made of soot and has a smooth consistency; it is therefore harder to lift than the granular Ivory Black,

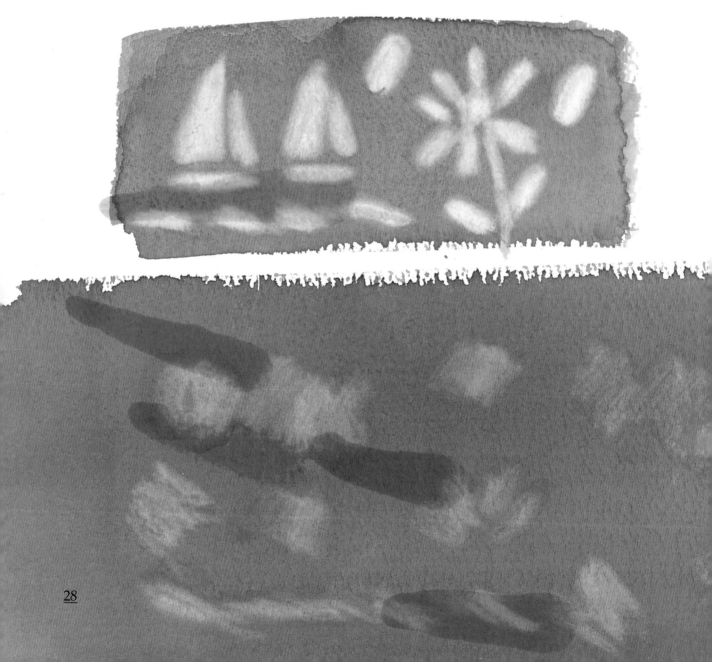

which can be used with plenty of water to make an easily lifted grey sky.

For a blue sky, use Cerulean Blue, Ultramarine or Cobalt, which all have a granular structure. Add even a drop of Prussian Blue and you can forget about ever getting it off the paper.

Make your own reference chart by preparing washes of ten or fifteen colours and then lifting them with a sponge or cotton-wool ball. The colours below show an Ultramarine mix on the top, easy to lift so the sketches show up well, and a Prussian Blue mix on the bottom – impossible to lift more than a minimal amount, as you can see by the useless scratch marks!

GRANULAR COLOURS WHICH LIFT EASILY
Rose Madder, Cerulean, Manganese Blue, Cobalt Green, Cobalt Violet, Permanent Mauve, Ultramarine Violet, Viridian, Raw Umber, Cobalt Blues, Ultramarine, Raw Sienna, Ivory Black.

Note: Cadmium Red has changed structure and is now a granular pigment which lifts easily, while the other Cadmiums remain stains.

OTHER PIGMENTS (BESIDES CADMIUMS) WHICH STAIN AND DO NOT LIFT
Aureolin, Alizarin Crimson, Permanent Rose, Prussian Blue, Venetian Red, Brown Madder, Gamboge, Permanent Magenta, Hooker's Green, Permanent Sap Green, Olive Green, Van Dyke Brown, Indigo, Payne's Grey.

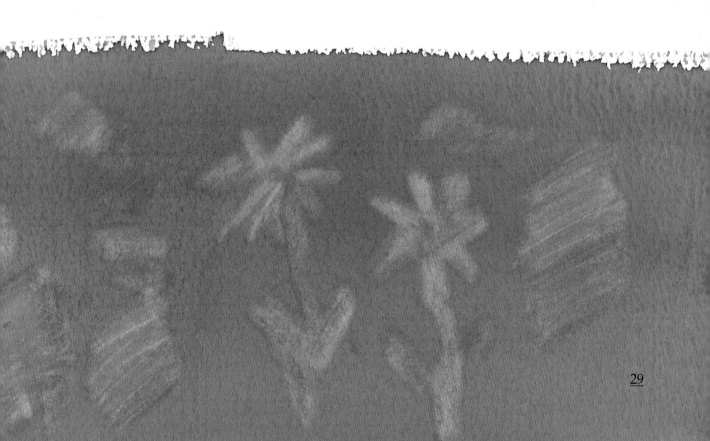

Transparency

The abiding quality which appeals to almost all watercolour painters is the lovely transparency of wash. The source of this phenomenon is the light, which passes through the pigment onto the white paper and is reflected back to your eye, creating an impression of a film or veil of colour.

Traditionally, wash has been employed by watercolour artists in layer upon layer, creating shadows and depth by minute degrees. To control this, you will need to be aware of how much of a particular pigment is required.

For example, if you are creating a pink wash, you need only a drop of Alizarin Crimson. But with Rose Madder you would need to add much more pigment to achieve the same result, yet not too much or the

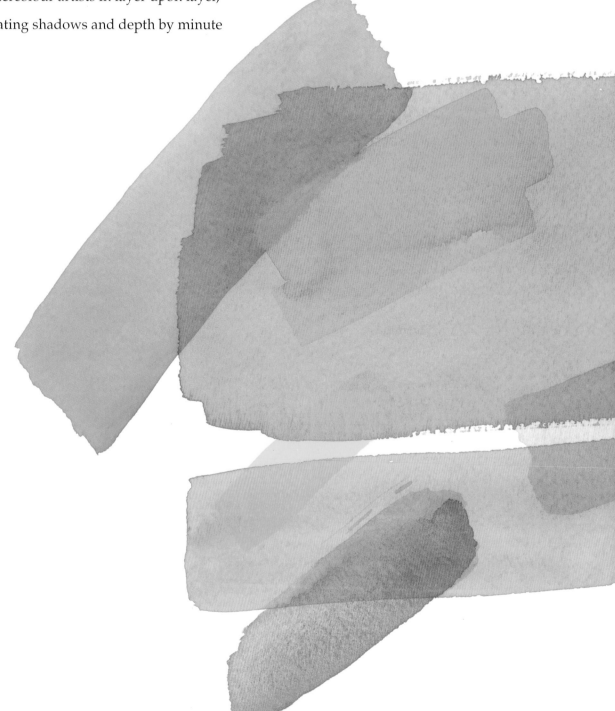

colour will deepen into an unwanted browner tone.

In putting one wash over another, you will get a more effective result from the staining colours that produce delicate washes, as in the case of the green and Cadmium Yellow on the Alizarin Crimson below. Using opaque colours for the same layers will produce a muddier mixture –

see, fore example, the mauve washes below – because each wash is fighting to obliterate the ones beneath. Look at the samples to see how differently the colours behave when they are laid one on another.

Avoid using a pigment like Yellow Ochre in a layer of three of more washes, because it will always tend to muddy any mixture (bottom right). When you buy new paints, you can check the colour charts to see the degree of transparency each colour achieves.

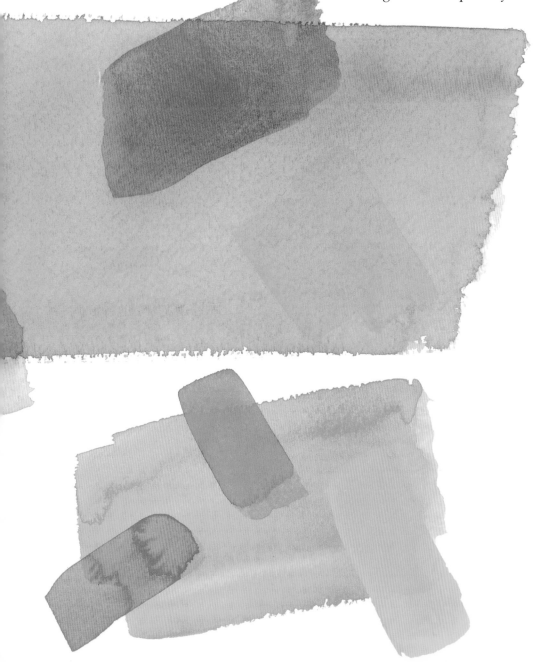

Opacity

The quality of opacity is not intrinsic to watercolour painting except if paint is used as gouache, straight from the tube. Of course no watercolour is completely transparent, and none is completely opaque – they are officially listed as semi-transparent and semi-opaque.

None the less, there is an appreciable difference in covering ability between the two extremes. And this becomes vital in mixing, when to emphasize a desired opacity you may need to choose alternative colours.

As an example, Cadmium Yellow and Lamp Black will give an opaque green, while Lemon Yellow and Ivory Black achieve a more transparent wash.

Cerulean Blue and Cadmium Red create a more opaque violet than the violets on sale. On the whole, the blue pigments are more transparent, the yellows are mixed, the reds which tend towards orange are opaque, while the reds which tend toward crimson purple and blue are not.

While blacks are strong enough to cover most colours, Lamp Black is denser. Ivory Black and Neutral Tint are slightly more transparent.

In addition, a more opaque pigment in a mix might change the texture of the wash, as well as obliterating more of the base layer.

On the opposite page I have painted two versions of autumn leaves, one using transparent colours Sap Green and Cobalt Green Pale, the other with more opaque mixes Terra Verte and two washes of Cobalt Green Pale. You can see that, however subtle, there is a distinct difference in effect, which would be emphasized if you were looking at a complete painting.

If you wanted to create a glimmering study with hints of colour then you should choose the transparent alternatives, while for strength and positive effects you might try more opaque colours. This is assuming that the pigments are all watercolour, without the addition of white, which would, naturally, add opacity to any of the colours.

Try out as many combinations as you like for yourself. Start with a basic outline drawing, and copy, or even photocopy it, at least three or four times. Then with varied groups of colours, choosing from the many mixes available, paint the first layer and then overpaint with additional layers, and see the subtle difference which the more opaque colours will create.

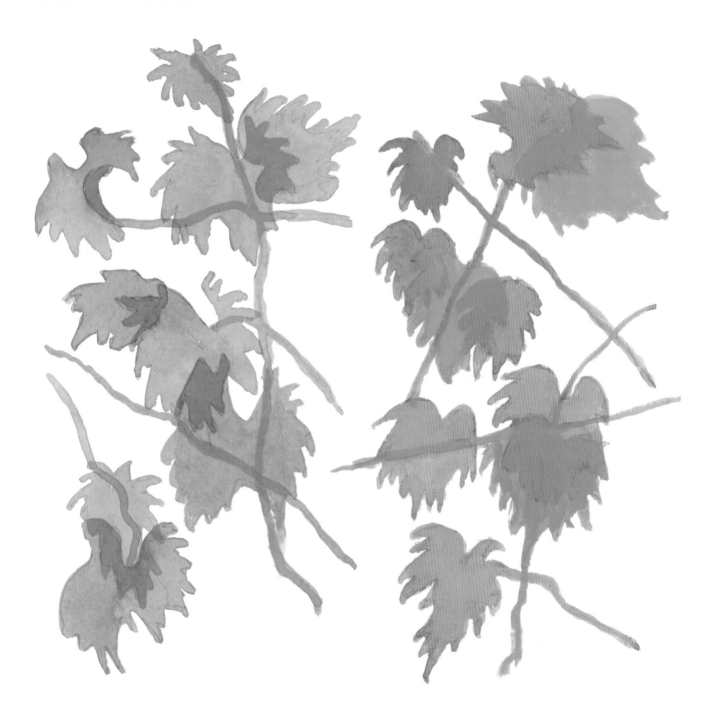

Sap Green and Cobalt Green Pale **Terra Verte and two washes of Cobalt Green Pale**

Strength and Weakness

Looking back through the history of watercolour paints, the first colours made from natural inorganic material (the earth colours and coloured stones) or natural organic material (vegetable and animal matter) were generally delicate and subtle. These are called weak colours.

Using 19th- and 20th-century techniques involving chemicals, metals and synthetics, we can now achieve really strong colours which retain their brilliance.

However, even these vary in their strength – some modern colours such as the Cadmiums are not as strong as the two 'killers', Alizarin Crimson and Prussian Blue. These will dominate any colour they are near, and

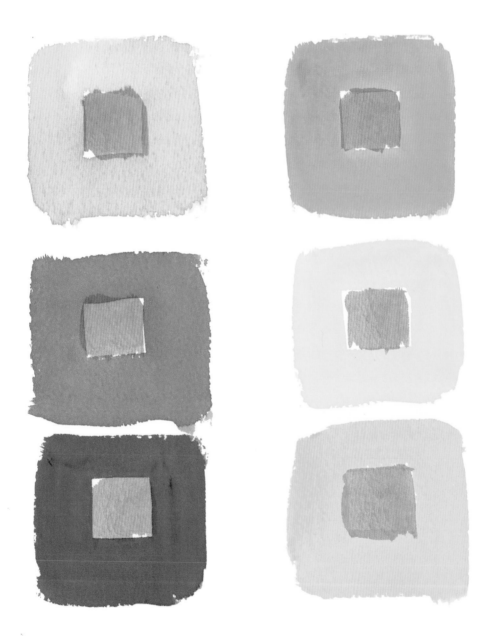

although it may be repetitious to say so, they must be handled with extreme care.

To show the additional effect of how colours can seem to expand or shrink according to their strength or weakness, I have chosen the extremes; a weak grey and the stronger greens and yellows in a contrasting set of squares below. The yellows and greens, light as they are, dominate the greys. The bright green centre holds its own against the red, but even the most vivid yellow is no match for the full power of the Ultramarine in a triple wash. There is an optical illusion that makes the inner squares appear to grow smaller the stronger the colour that surrounds them.

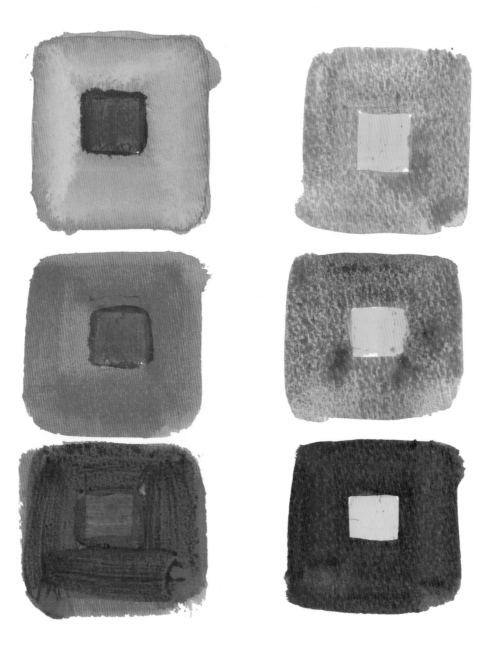

Mixing Technique

MIXING TWO COLOURS

As a practical matter, in mixing any two colours together you always begin with the lighter of the two and add the darker one. This is an absolute – anything else is a complete waste of pigment, as you might have to add an entire tube of lighter colour to counteract the effects of beginning with a dark one.

Things become more difficult when the colours are similar in tone and strength. If you are planning to make a purple from Cadmium Red and Ultramarine, it may seem obvious that the blue is darker, and that you should therefore start with red. But in practice, because of the opacity and strength of the Cadmium Red, you begin with the blue and only add the red drop by drop. Doing it the other way around would mean adding so much Ultramarine to the red that you would end up with far too much paint on the palette.

The best way to work out which colours are more powerful than others is to consider first the obvious – yellow is lighter than brown – then their transparency or opacity as shown in our colour codes, and then experiment!

You will find that one colour for no apparent reason dominates the other and should be added second; others which appear to be strong colours, like Viridian or Cadmium Red, are in fact weaker than the new Pthalo Greens, which, by the way, need to be used with almost the same care as the 'killer colours', Alizarin Crimson and Prussian Blue.

Two-Colour Mixes

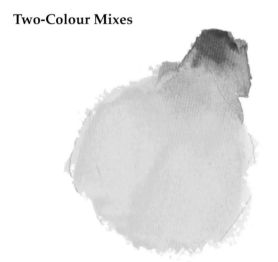

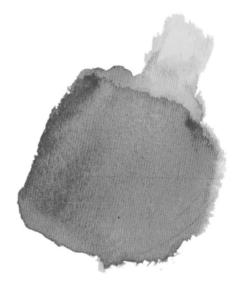

1. The right way to start the mix: Cadmium Yellow with a drop of Alizarin Crimson.

2. The wrong way: If a drop of Yellow is added to the Crimson it will simply disappear.

MIXING THREE COLOURS

WARNING: The danger is that anything more than two colours may give you a muddy result, so using three is really a last resort. And remember that some of the colours you buy are actually mixtures already — Olive Green, for example, is made up of two or even three colours, so that if you mix in yet more you will end up with as many as six or seven, and the result will be a muddy mess.

Check the contents of the colours on the manufacturer's chart. Olive Green, Hooker's Green, Sap Green, Rose Madder (but not Rose Madder Genuine), the Scarlets, Vermillion and modern Gamboge among others are mixtures.

Three-colour mixes are useful when you need to achieve a particularly subtle mix, for example, a greyish green or a green from two blues and one yellow, which would give you quite a different shade than that made from just the one blue and one yellow. Or two reds with one yellow for a particular orange, or two blues to one red for a particular shade of violet or mauve.

To make a green with two blues, begin with the yellow as usual. Add a very small quantity of one blue, and then the very tiniest quantity of the second. Keep adding the blues alternately until you achieve the colour you want.

You should avoid mixing four or more colours unless you are willing to be very careful and add literally a drop at a time. With almost no warning the colours will become dull and boring.

Three-Colour Mixes

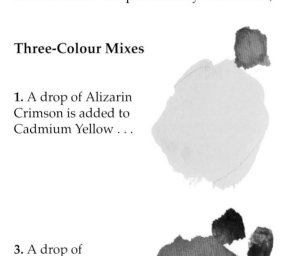

1. A drop of Alizarin Crimson is added to Cadmium Yellow . . .

2. . . . and mixed.

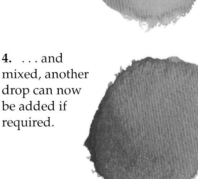

3. A drop of Cadmium Red is added . . .

4. . . . and mixed, another drop can now be added if required.

Laying Mixed Washes

To build up multiple washes with two or more colours, you will want to lay washes one over another, making sure that the first is absolutely dry before you continue.

The effect is different from simply mixing the two colours on the palette, partly because of the layered or veiled effect and partly because each wash will be slightly uneven, and therefore the finished effect will have more variation and tonal impact.

The result will be affected by the nature of each pigment and the sequence in which they are used. An opaque wash laid over a transparent colour will diminish the first colour; reverse the sequence and the two are in more equal balance. The difference is marginal, but can make a significant difference to the final painting. And the

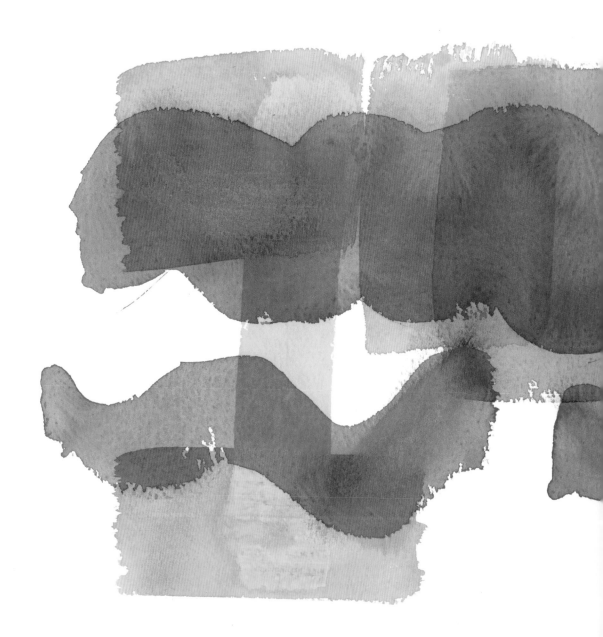

stronger the washes, the greater the difference.

In making multiple washes of three colours or more, the best effect will be achieved if you start with an opaque colour and use transparent colours for the top washes.

But remember that just as mixing too many colours in the palette can be self-defeating, using too many layers will end up negating any subtle effects and you will get nearer and nearer a grey. Looking at the colours below you will see that those on the right where the layers are beginning to pile up are getting more and more subdued, losing the clarity of the originals.

All the previous comments and examples assume you are working on white paper – for working on tinted paper see the following pages.

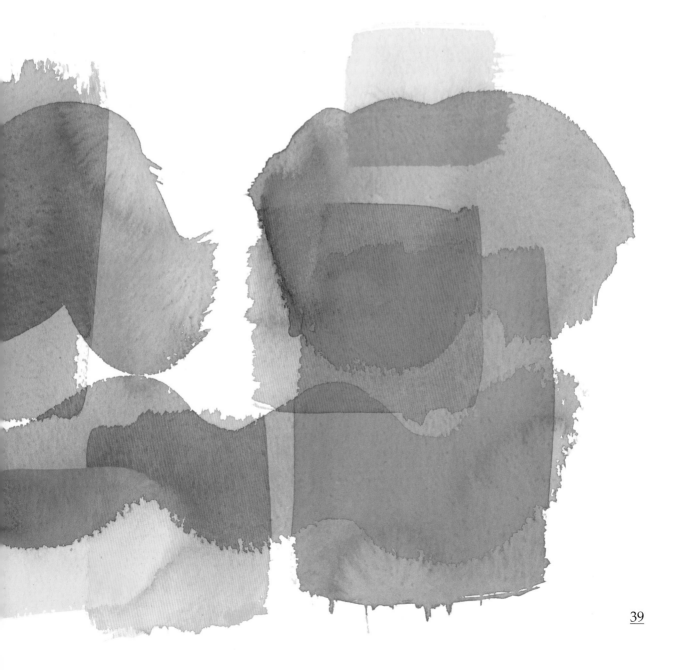

Working on Tinted Paper

For particular subjects you may choose to work on tinted paper. Clearly, since watercolour is fundamentally translucent, any colour will be changed by the tint. However, some will be more affected than others.

If your paper is grey, then the brilliance of every colour will be reduced, albeit slightly.

If you chose to work on an ochre, cream or pale yellow paper, all the earth colours would be intensified; for example, Burnt Umber would shift towards Raw Umber, and Burnt Sienna towards Raw Sienna. The yellowish tint would also warm the greens and blacks, so that Viridian would shift towards yellow-green, and an Ivory Black would take on brown overtones.

Alizarin Crimson and Cadmium Orange

Ultramarine and Yellow Ochre

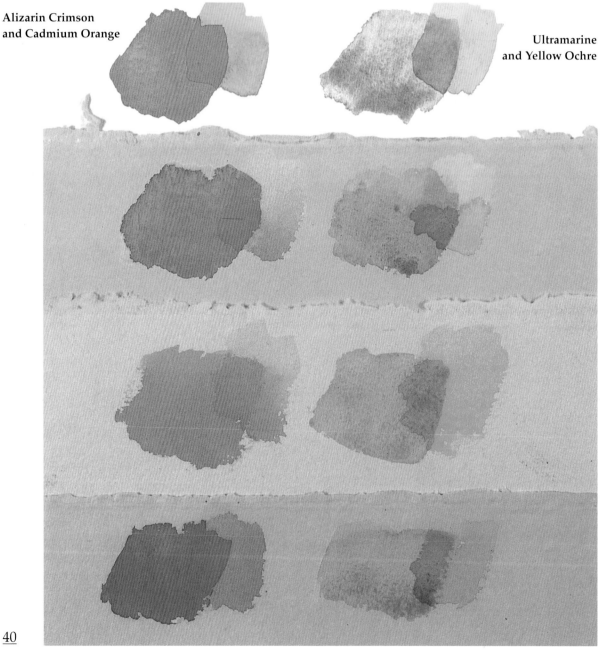

If this is what you intend, then fine. But if you want to keep colours the same as they would be on white, you have to mix your paints very carefully in order to counteract the effect; for example, mixing Burnt Umber with a little black will cool it down. On a green paper, the shift will be towards cooling down the colours, so you would need to add a touch of Hooker's Green to Viridian to warm it up.

I believe this is working against the paint, not with it. Much better to choose tinted papers for their effect, and choose the shifts towards warm or cool because that is what you want in your painting.

Study the various papers below and see how colour changes as it moves over the tints. Then experiment for yourself.

Cadmium Yellow and Viridian

Neutral Tint and Mauve

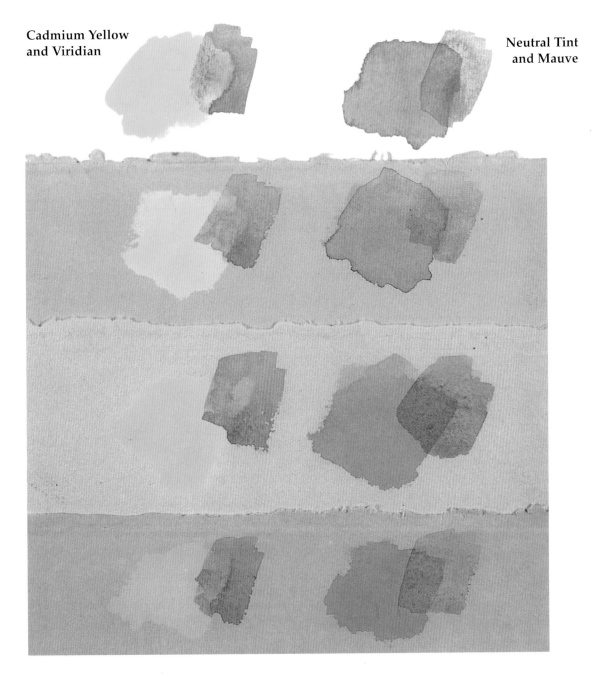

Mixes for Skin Colours

Portraits or figure studies can be very disappointing, partly because catching a likeness can be difficult at first, and partly because skin is a particular problem for the watercolourist.

Human skin reflects light, and most of the obvious mixes are inaccurate, especially those marketed as 'flesh' tones. I find them far too pink – except for sitters who are severely sunburned!

Instead, begin by looking carefully at your sitter (or yourself in the mirror) in reasonable light. Decide which tones predominate.

This page shows three mixes for light skin, beginning at the top with Rose Madder and Lemon Yellow, Scarlet Lake and Indian Yellow, and Cadmium Red Deep with Cadmium Yellow Deep. All three were made with one light wash.

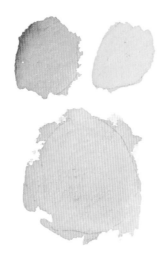

Rose Madder and Lemon Yellow

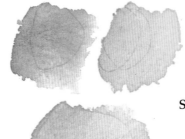

Scarlet Lake and Indian Yellow

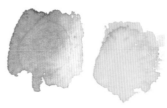

**Cadmium Red Deep
and Cadmium Yellow Deep**

On this page I have indicated some of the mixes you might use for darker skins. The first is Raw Umber with Indian Yellow, the second Burnt Umber with Burnt Sienna, and the darkest is Van Dyke Brown, cooled even more with Neutral Tint.

All these combinations can be modified to suit both your sitter and the light. Skin will reflect light from the sky but also from a strong background, so that if you paint your portrait against a dark green or vivid red background, the face will pick up a lot of colour, especially in the shadowed areas.

Try to keep to two colours, and if you have to add a third, either use it very sparingly or only in the darker areas. Try different reds, yellows or browns in varied quantities, and mix enough basic wash to paint the whole face.

Raw Umber and Indian Yellow

Burnt Umber and Burnt Sienna

Van Dyke Brown and Neutral Tint

Sky Mixes

Another problem area, yet essential to the land- or seascape artist. Most traditional scenes have over half their space devoted to the sky, so it's no wonder it can prove a sticking point. And things are even more difficult because there are constant variations as the seasons change and the sky turns from clear summer blue to the icy grey of winter; in the same way, the pale light of early morning gives way to the more intense noontime sky, and finally to the brilliant streaks of colour at sunset; and then, of course, there are the violent changes due to the weather.

Start with seasons. Spring requires soft, light washes, with the blue having a special

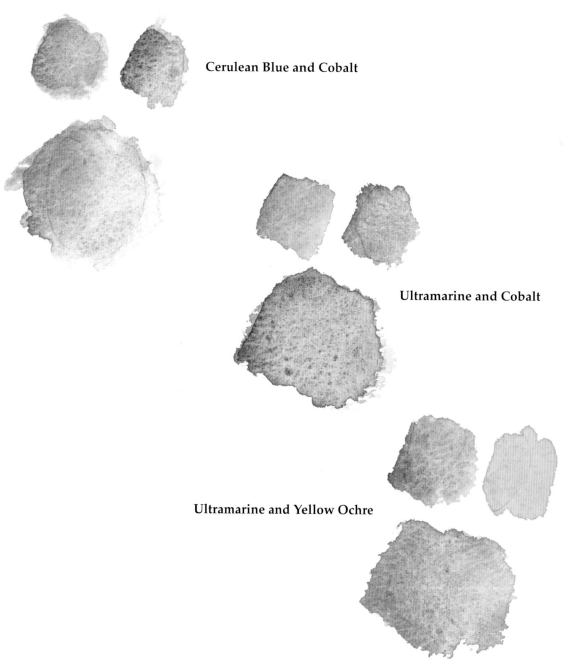

Cerulean Blue and Cobalt

Ultramarine and Cobalt

Ultramarine and Yellow Ochre

translucency that can be breathtaking – and hard to match! Try using Cerulean Blue with a tiny touch of Cobalt, as I have in the first example. (Or palest Ochre, the palest Sap Green and a wash of Lemon Yellow on top, and you've painted April!)

In summer, there are sharp, blue skies made from Ultramarine and Cobalt.

In winter, misty skies, still clear, require Ultramarine greyed down by Yellow Ochre.

The stormier skies below use Prussian Blue and Raw Umber, then Prussian Blue with Neutral Tint, and third, no blue at all, but Neutral Tint and Yellow Ochre to make a satisfyingly rain-filled cloud.

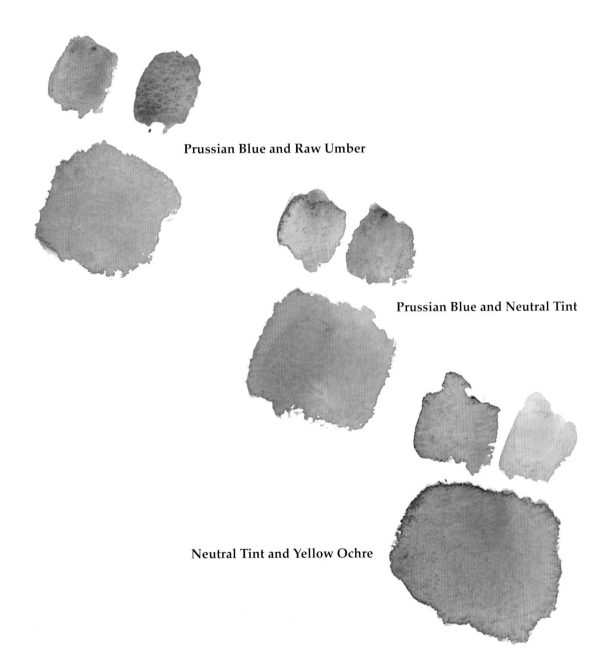

Prussian Blue and Raw Umber

Prussian Blue and Neutral Tint

Neutral Tint and Yellow Ochre

TWO-COLOUR BLENDS

The top blends are one wash, the bottom blends have two washes to intensify the colour. Both start with a wash, showing the many graduations between two colours. On the right I have isolated three intermediate colours that I find especially useful.

LEMON YELLOW/COBALT BLUE

Lemon is cool green, so it mixes well with Cobalt, or indeed with any blue. Cobalt is neutral, neither green nor red, so any combinations of these two will be bright and clean. They make a lovely spring lime, the stronger washes a rich blue-green.

Single wash

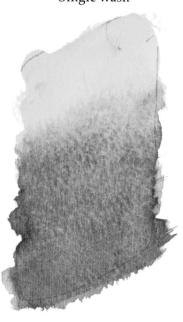

Intermediate colours

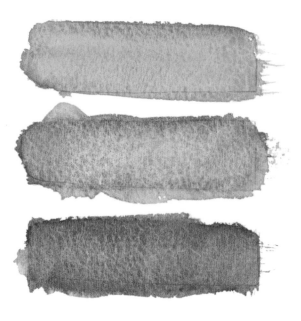

Double wash

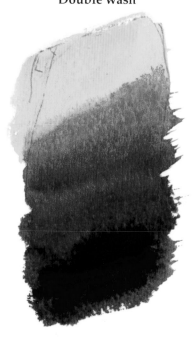

Intermediate colours

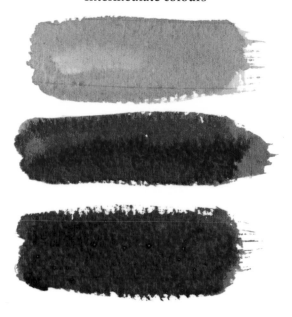

CADMIUM YELLOW/COBALT BLUE

Cadmium is a warmer yellow with a touch of orange, and you can easily see that the change gives the lighter wash an olive tinge. The deeper washes, too, are much warmer in tone, the autumn greens for landscapes predominating.

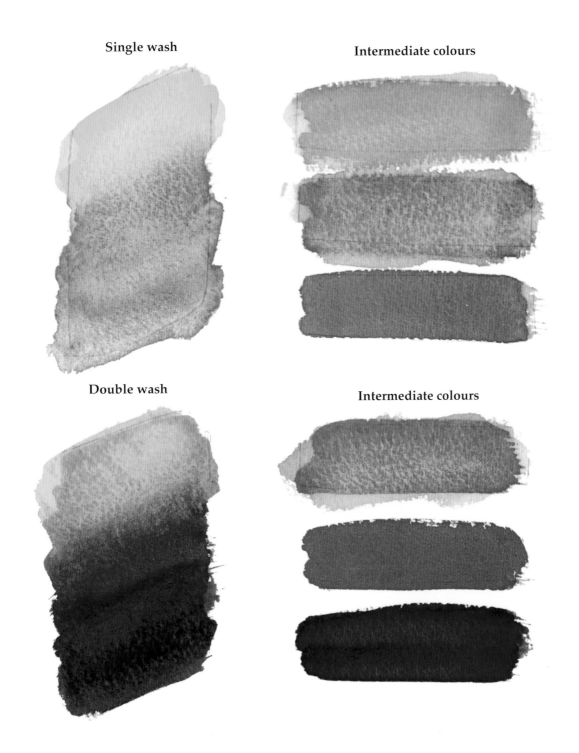

Single wash

Intermediate colours

Double wash

Intermediate colours

CADMIUM YELLOW DEEP/COBALT BLUE

Here the yellow has even more orange in it, and the mixtures will give you a distinct grey hue. So much so that the heavier washes are verging on black.

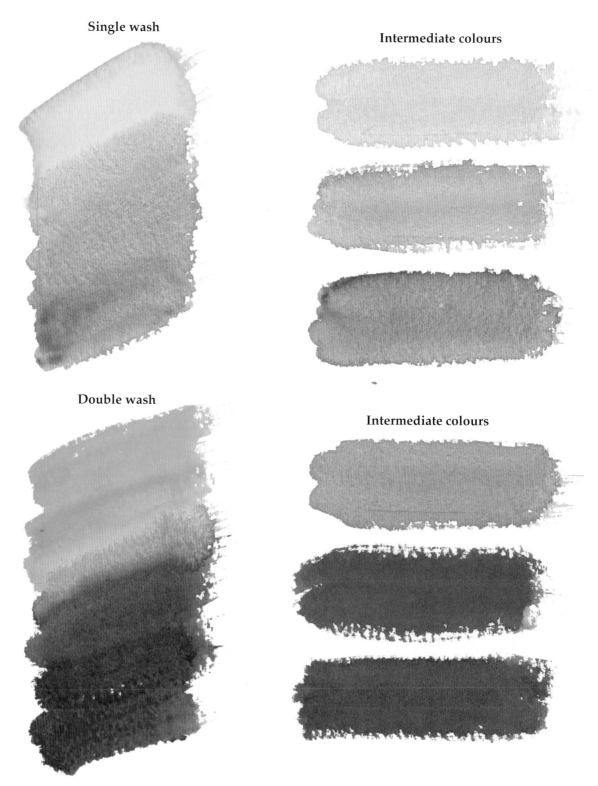

Single wash

Intermediate colours

Double wash

Intermediate colours

LEMON YELLOW/ULTRAMARINE

This is a standard mix when you want the coolest, clearest yellow and a mid-Ultramarine, neither warm nor cold. The result is a pale, neutral group, the darker wash verging towards a soft olive, but without the warmth that Cadmium Yellow gives.

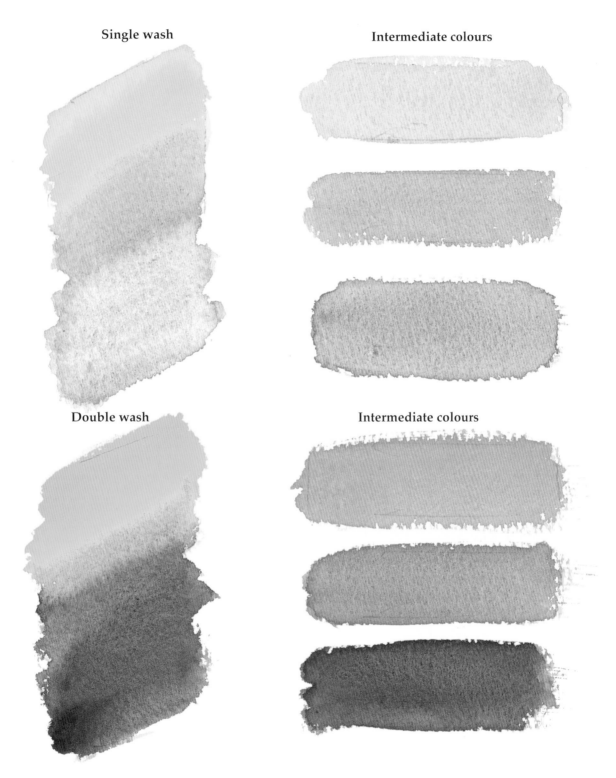

Single wash

Intermediate colours

Double wash

Intermediate colours

CADMIUM YELLOW/ULTRAMARINE

This is the most commonly used mix to create green. You can achieve the widest possible range from these two colours, although remember that some greens, like Viridian, cannot be made up from any mixture and have to be bought as pigment.

Single wash

Intermediate colours

Double wash

Intermediate colours

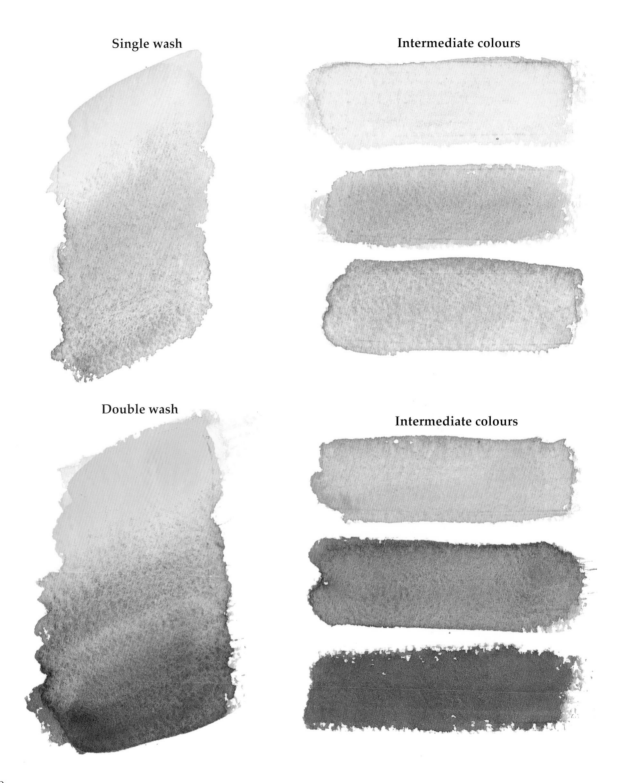

CADMIUM YELLOW DEEP/ULTRAMARINE

A richer and warmer development where the slight orange cast of the yellow has decreased the clear blue Ultramarine. In the deeper version the green has become the familiar forest green which we associate with pine trees.

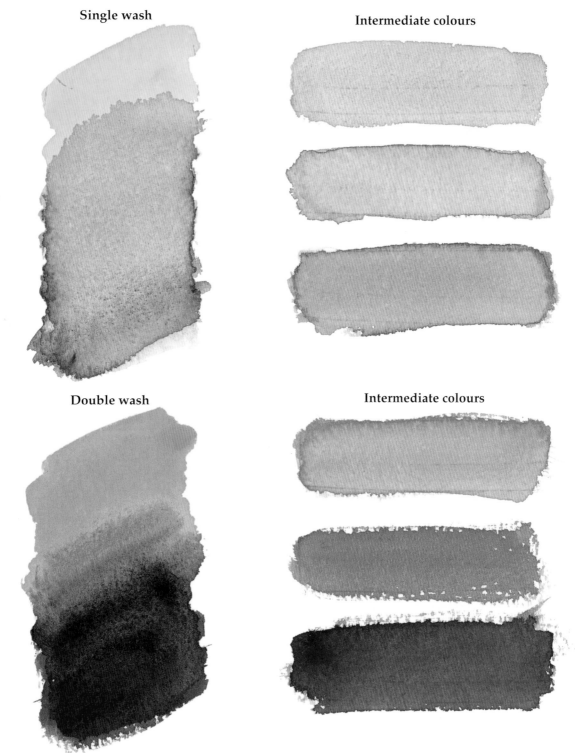

Single wash

Intermediate colours

Double wash

Intermediate colours

LEMON YELLOW/PRUSSIAN BLUE

These are much colder hues; the Prussian is a chilly greenish blue, so that the mixtures become very sharp and full of citrus tones which are quite particular to these two basics. No other yellow or blue will give the same acid, intensely tropical brilliance.

Single wash

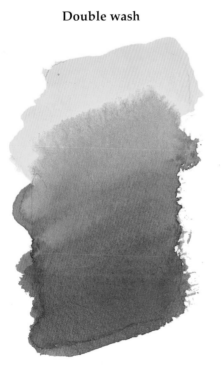

Intermediate colours

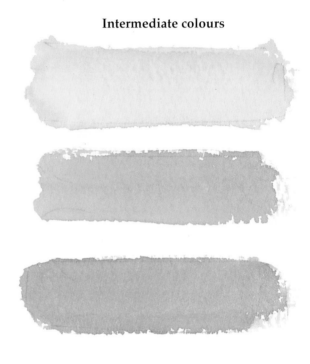

Double wash

Intermediate colours

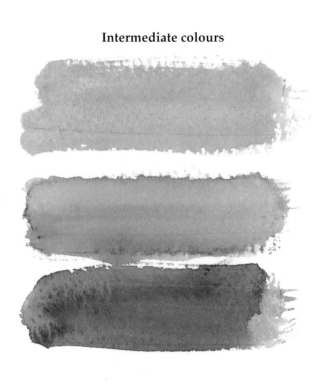

CADMIUM YELLOW / PRUSSIAN BLUE

The change is remarkable. Cadmium makes the greeny Prussian less intense, laying a soft greyish cast on the mix which will give you a good choice of cool blues.

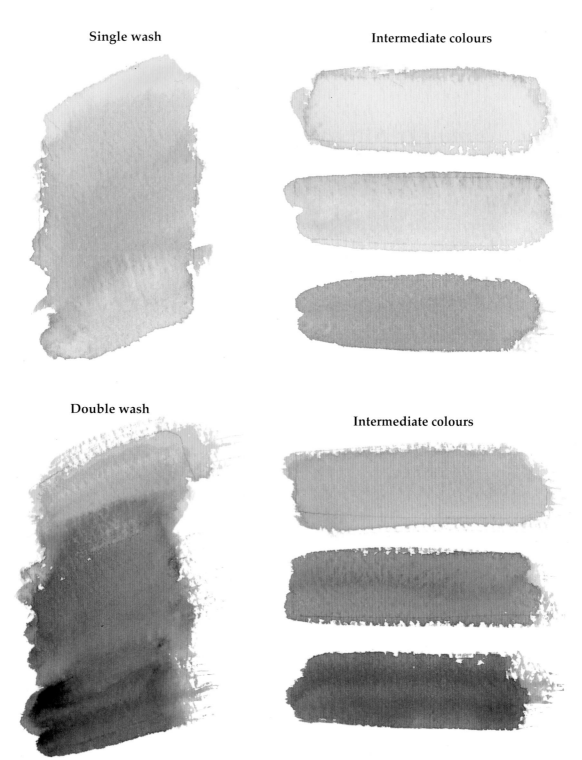

Single wash

Intermediate colours

Double wash

Intermediate colours

CADMIUM YELLOW DEEP/PRUSSIAN BLUE

You can see how pervasive this blue is; with just a few drops, both light and heavy washes are dominated by Prussian Blue's green cast. The Cadmium is vibrantly orange, and the whole range has moved to a cold, watery turquoise.

Single wash

Intermediate colours

Double wash

Intermediate colours

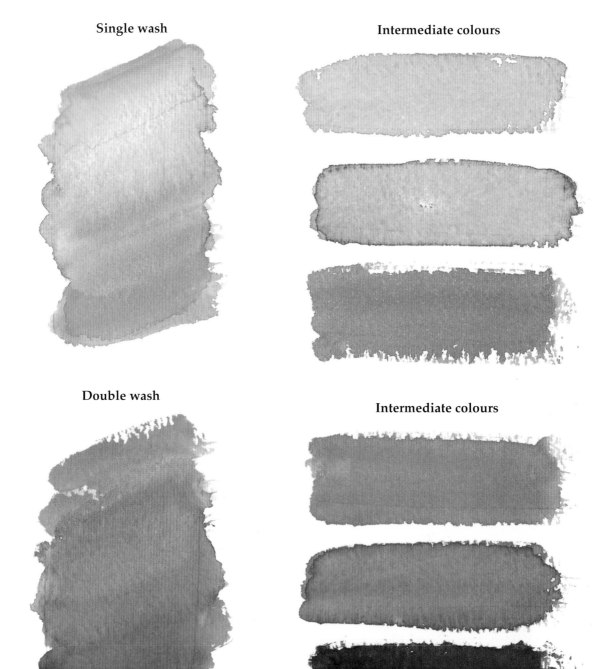

CADMIUM RED/COBALT BLUE

Cadmium Red is quite neutral and Cobalt is a clean colour. The combination creates a beautifully balanced range of soft pinks and lilacs. These are particularly useful for flower sketches, or for still life, or figures in evening shadow.

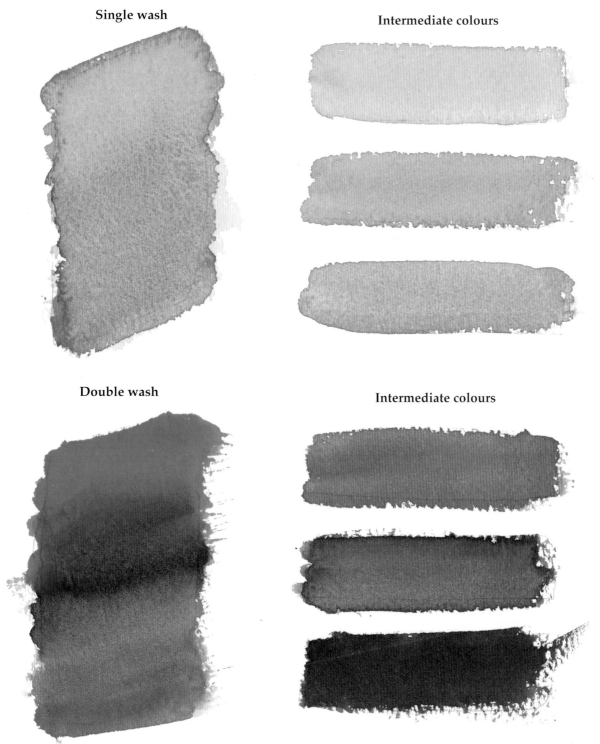

Single wash

Intermediate colours

Double wash

Intermediate colours

CADMIUM RED DEEP/COBALT BLUE

A strong, cold red, so that the mixes tend towards brown, with a greyed purple that is soft even in the deep wash. This is a subtle group of winter colours.

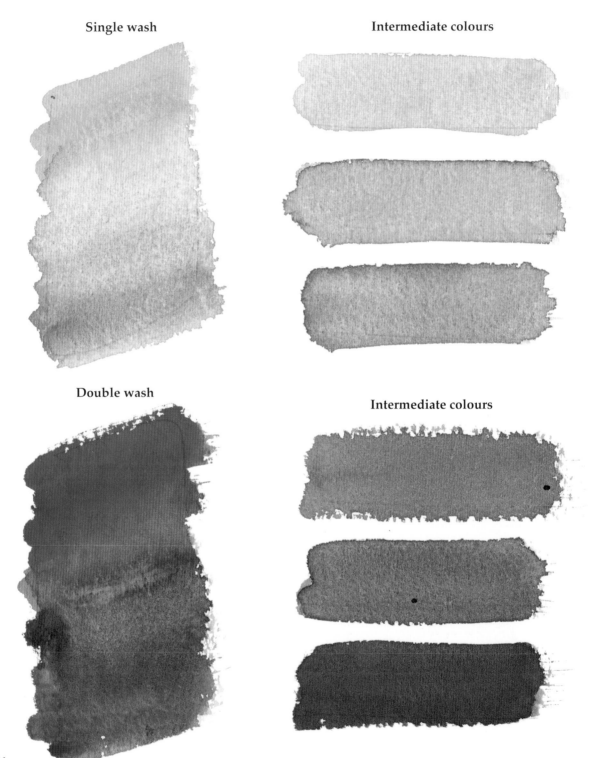

Single wash

Intermediate colours

Double wash

Intermediate colours

ALIZARIN CRIMSON/COBALT BLUE

This combination produces a very clean range of purples, rich and sensuous, more like ripe fruit than the dying autumn leaves of the previous mixture.

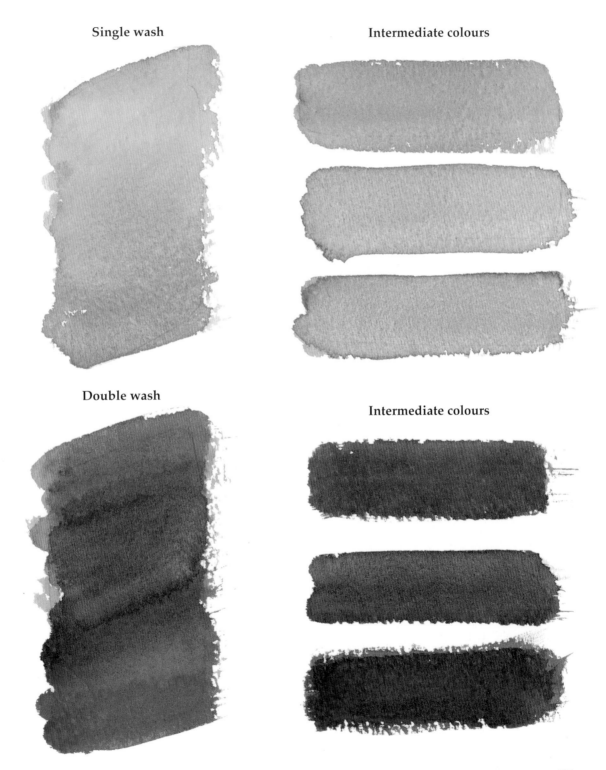

Single wash

Intermediate colours

Double wash

Intermediate colours

CADMIUM RED/ULTRAMARINE

Cadmium Reds are not particularly clean when mixed, so that the results are always slightly weaker and greyer than the other reds and blues. The resulting purples on both these combinations are grey, neutral and somehow dampened down.

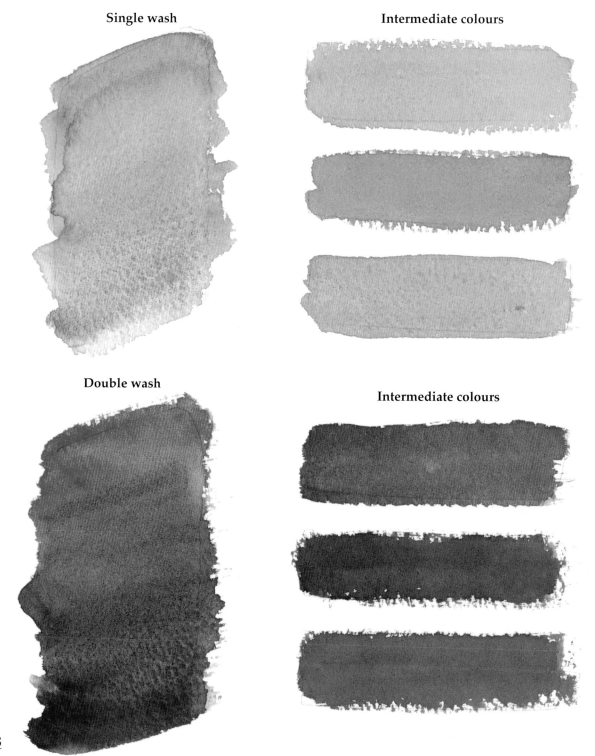

Single wash

Intermediate colours

Double wash

Intermediate colours

CADMIUM RED DEEP/ULTRAMARINE

The mix is colder than its basic colours. The difference from the previous combination only shows up in the stronger wash, where the neutral grey hues continue to predominate. Purple is notoriously difficult to mix when you need a precise tone.

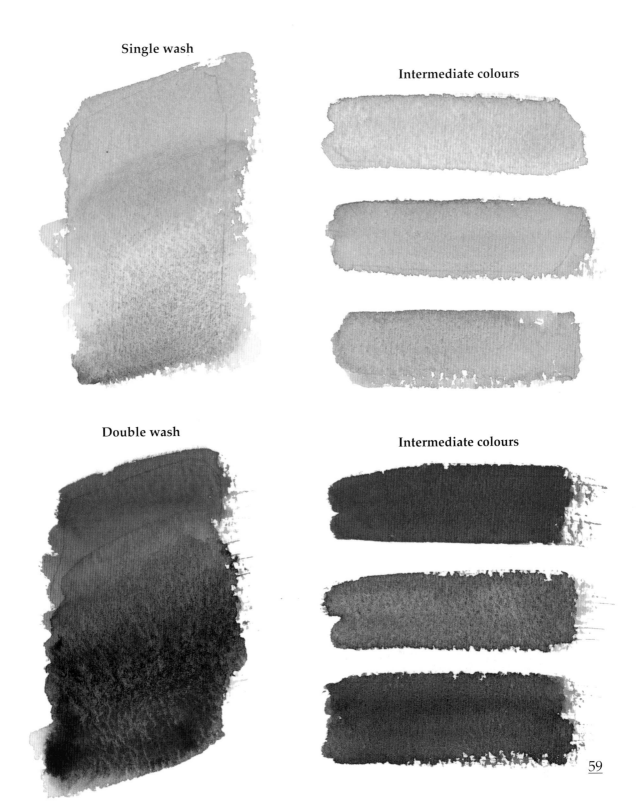

Single wash

Intermediate colours

Double wash

Intermediate colours

ALIZARIN CRIMSON/ULTRAMARINE

A rich bang of a colour combination, with strong warm reds and a rich blue making a wonderful range of purples and wines. Perfect for glowing interiors or fruits.

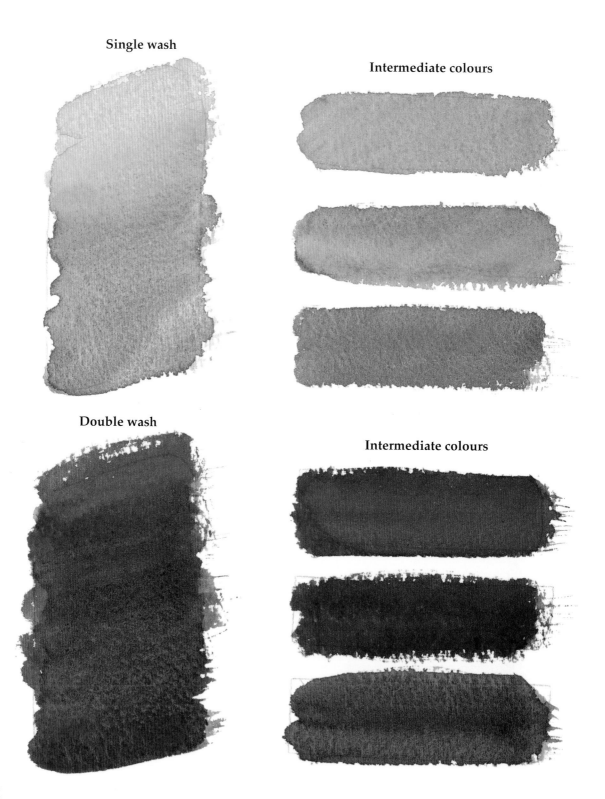

Single wash

Intermediate colours

Double wash

Intermediate colours

CADMIUM RED/PRUSSIAN BLUE

In the double wash, the green in Prussian Blue turns the red into brown. The variety of greys is unmatchable in commercially prepared colours. Absolute magic.

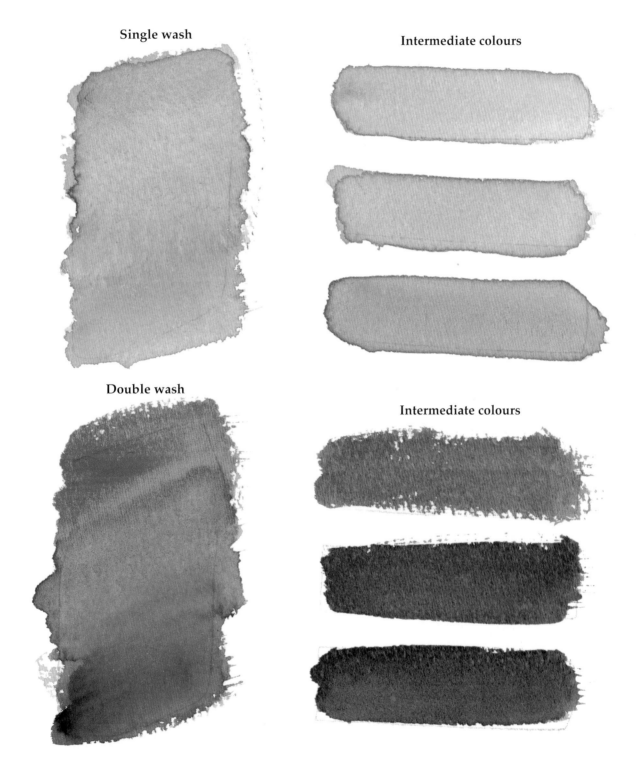

Single wash

Intermediate colours

Double wash

Intermediate colours

CADMIUM RED DEEP/PRUSSIAN BLUE

Here the colour is deepened into quiet, cool grey and browny storm colours. The warmth of the Cadmium Red is being neutralized by the Prussian Blue.

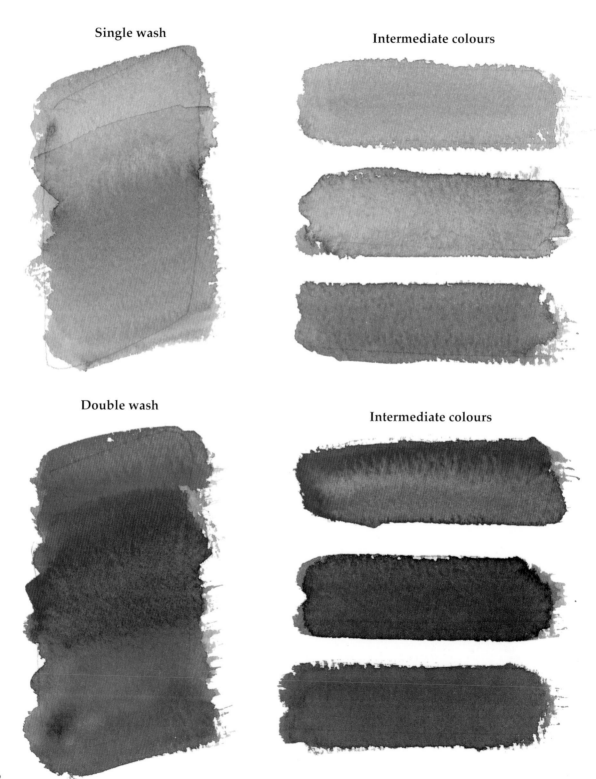

Single wash

Intermediate colours

Double wash

Intermediate colours

ALIZARIN CRIMSON/PRUSSIAN BLUE

Mauves, and winey reds, with the lighter mixtures giving soft purpley greys which are perfect for snow shadows, or the deep folds of black velvet dresses.

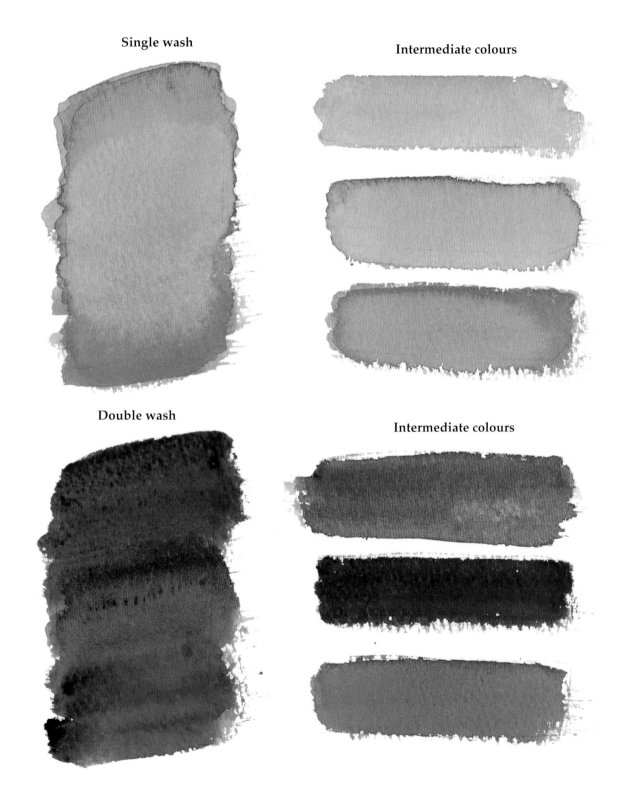

Single wash

Intermediate colours

Double wash

Intermediate colours

Variations on a Theme

These show the importance of choosing a second colour carefully. Each of a family of colours will create a very different mix.

3 GREENS/ULTRAMARINE

The three are, from the top, Sap Green, Hooker's Green, both already manufacturer's mixes, and Viridian. The first creates lovely olives, and the third makes watery turquoises. But the first two examples will vary greatly according to which make you are using.

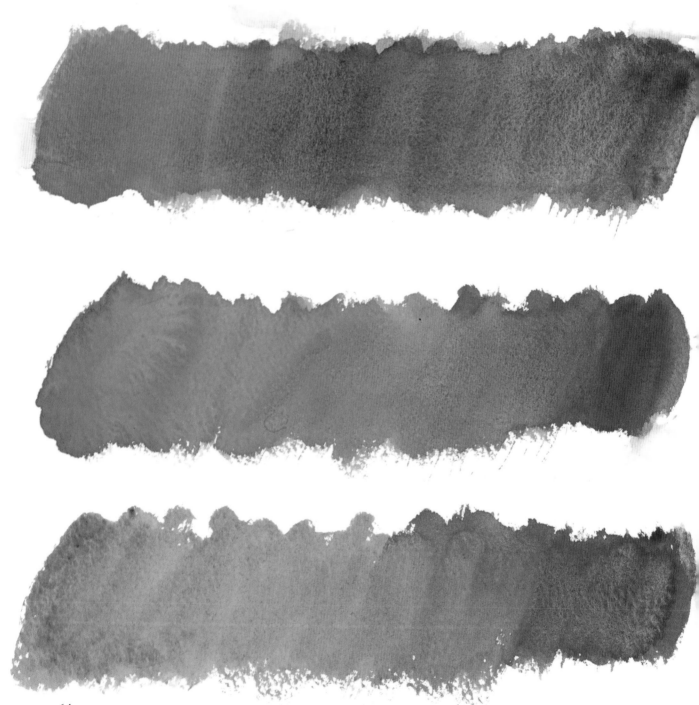

3 YELLOWS/BURNT SIENNA

The yellows are, from the top, Lemon, Cadmium and Gamboge, creating a wide range of orange-browns. Burnt Sienna is a wonderful tool, giving a rich chestnut tinge to all the yellows, and making them look like they are on fire.

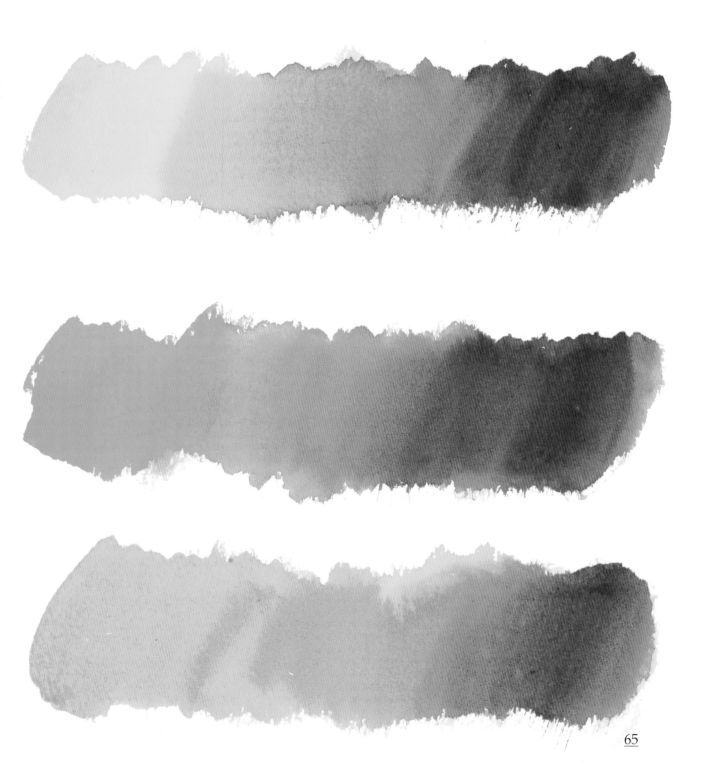

3 YELLOWS/BURNT UMBER

Here are the same three yellows, Lemon, Cadmium Deep and Gamboge with a dark Burnt Umber, making softer chestnuts.

The browns are quiet, the autumn of an English lane rather than the flaming maple trees of America.

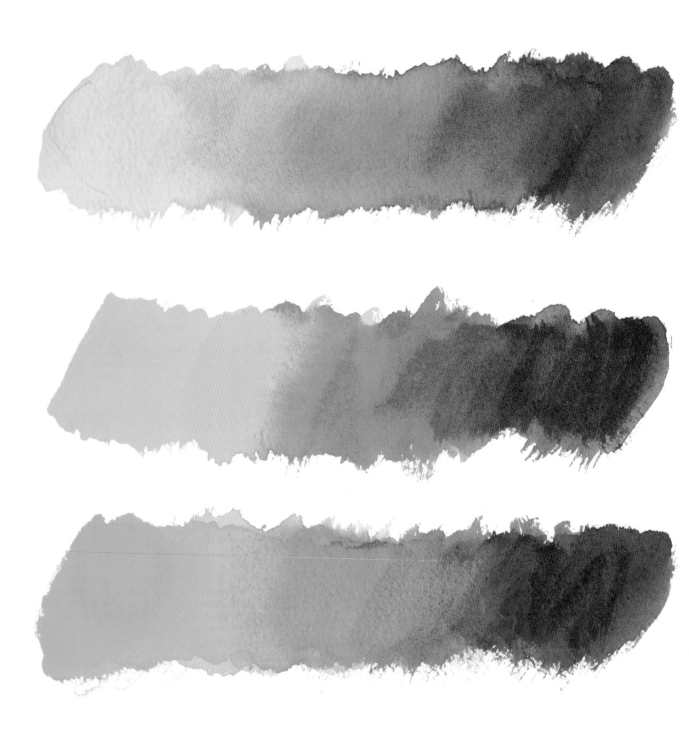

3 YELLOWS/IVORY BLACK

Lemon Yellow, Cadmium Yellow Deep and Gamboge show green made from yellow and black instead of yellow and blue.

The mix is an unripe melon rather than a true green, so it needs more work to produce the hue you want.

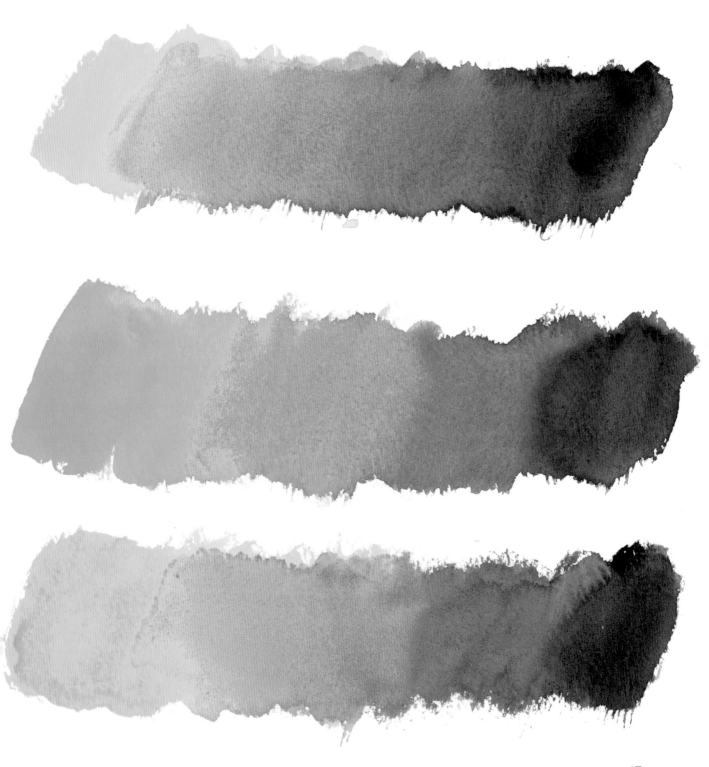

3 YELLOWS/VIOLET

Lemon Yellow, Cadmium Deep and Gamboge have produced some unusual mixes. The Lemon is a dead colour, an unripe banana, while the others are much livelier – ripe pineapple, perhaps. Perfect for mountain shadows, or distant meadows.

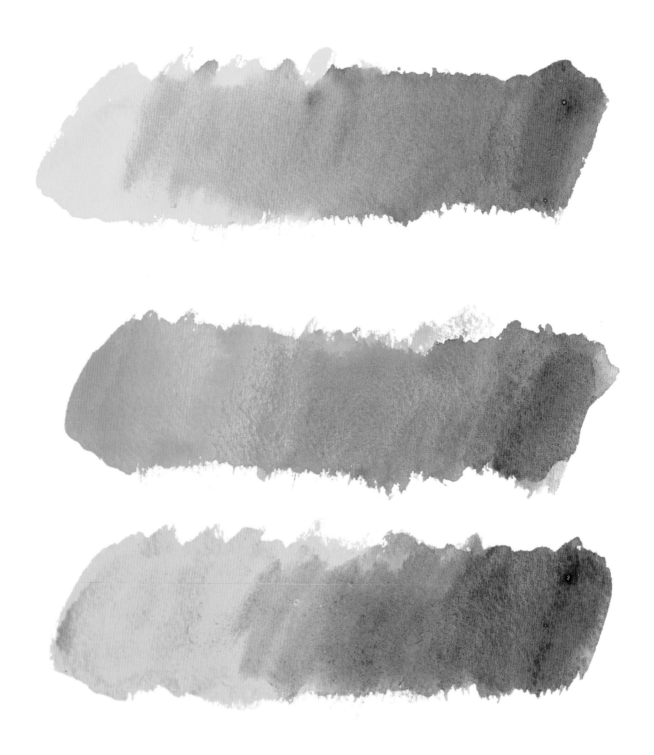

YELLOW OCHRE/3 BLUES

Cobalt (top) has turned the Ochre into a smokey colour for a stormy sky, while the Prussian mix (bottom) is distinctly green.

In complete contrast, the Ultramarine/Ochre has created a curious clouded chestnut. Marvellously subtle and full of mystery.

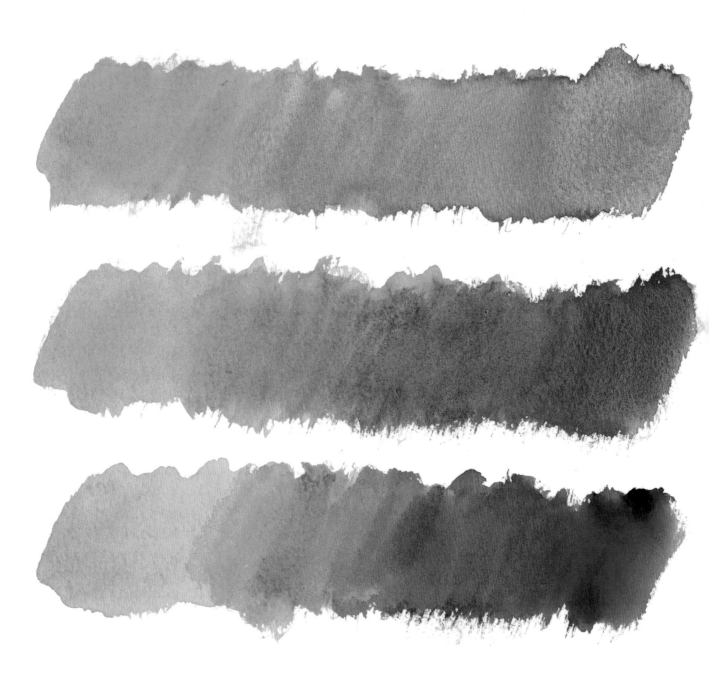

YELLOW OCHRE/3 BLACKS

Not quite; I started with Sepia first (top), then Lamp Black (centre) and finally Ivory Black. The Sepia mixes so smoothly that you get a light evening shadow that shimmers like soft taffeta. Lamp Black/Ochre created a curious texture, leaching into the paper, while the Ivory Black/Ochre is cold and dirty looking.

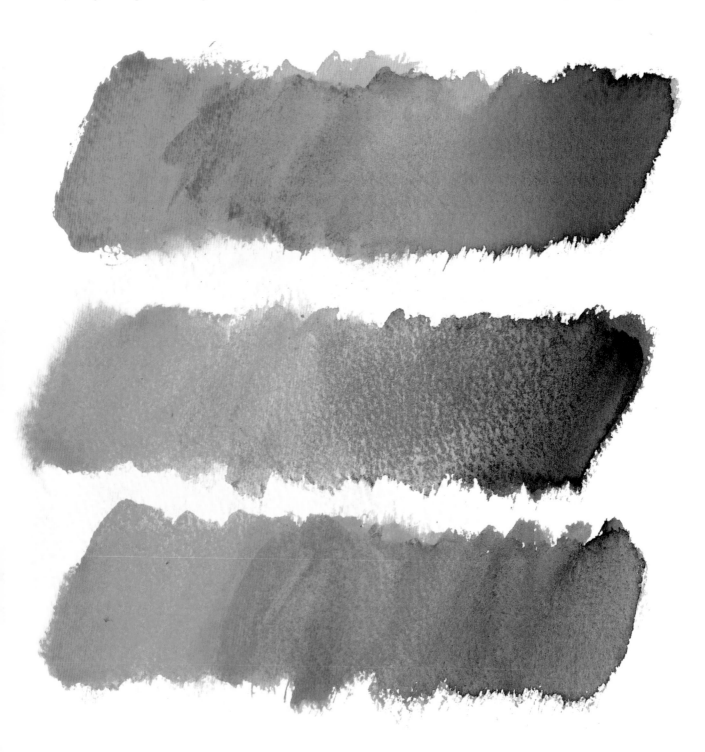

YELLOW OCHRE/3 GREENS

Using, from the top, Cobalt Green, Hooker's Green and Viridian, see how some mixtures fight each other on the paper (the centre mix), while the top and bottom greens blend smoothly into the Ochre. Due to granular pigments, for special effects it takes experimentation to sort out which mixes will react this way.

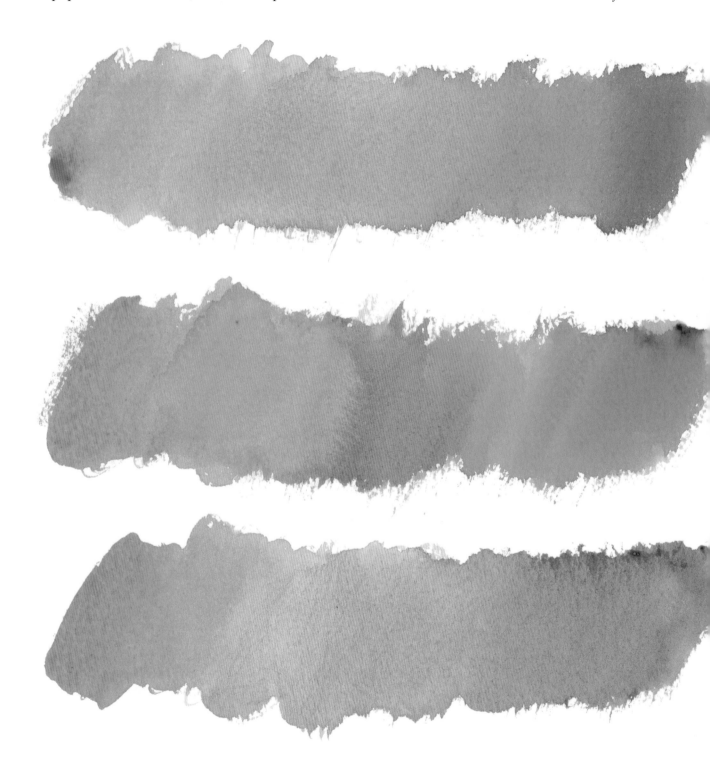

YELLOW OCHRE/3 REDS

A new mix for me, using Scarlet Lake, Cadmium Red and Alizarin Crimson. The orange tones in the Ochre have created a remarkable group of subtle apricots. Without this trial I might have used conventional brighter yellows or orange.

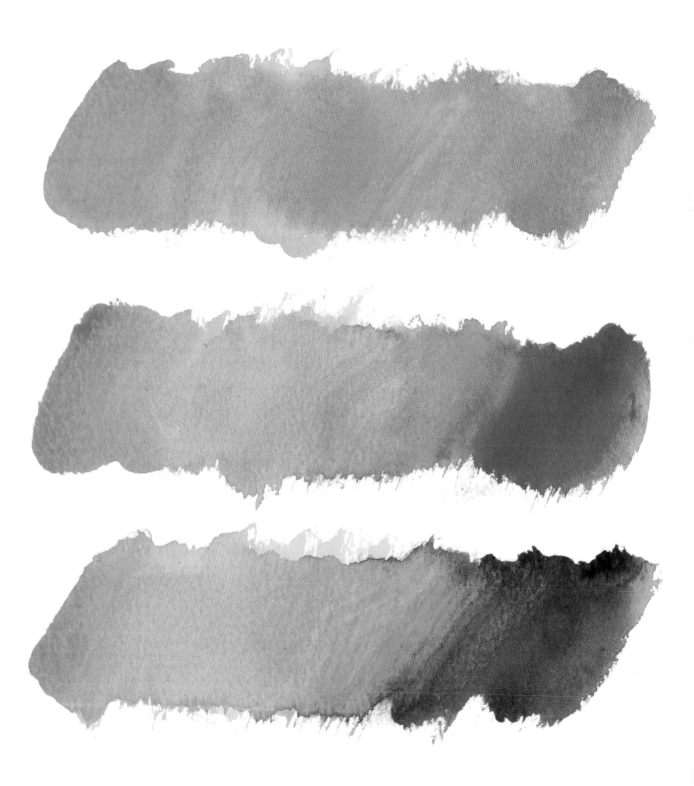

I have chosen to mix my Colour Codes in fairly broad, flourishing brushstrokes because I feel it gives the most exciting result in by letting you see all the subtle gradations between the two colours.

But you may prefer a more measured approach, working on a grid. Below I have illustrated one for Cadmium Yellow mixed with different greens. Each horizontal line begins with the yellow, then a 75/25 per cent mix, an equal 50/50 per cent mix in the centre, a 25/75 per cent and then the pure green.

While this does make it easy to see what proportions you should use, to get the best effect you need to make the grid at least double and preferably triple the size of this one, so that the quality and texture of the painted squares can be studied.

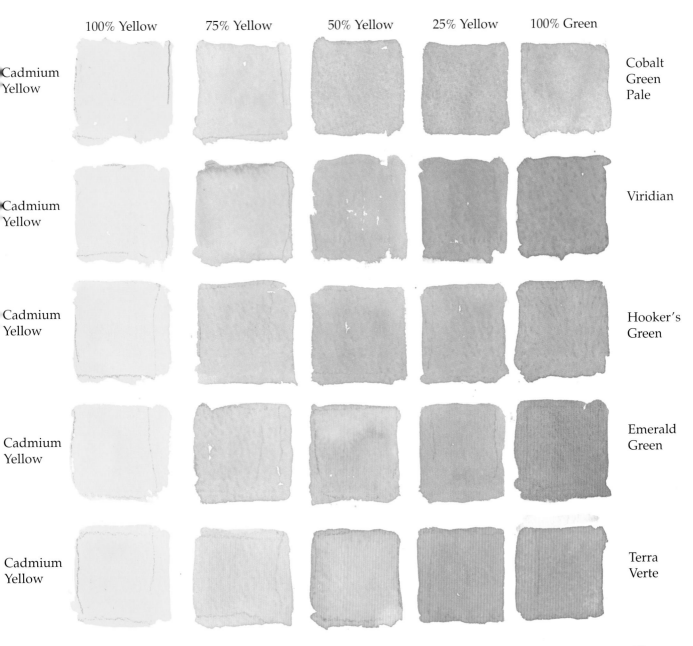

100% Yellow	75% Yellow	50% Yellow	25% Yellow	100% Green	
Cadmium Yellow					Cobalt Green Pale
Cadmium Yellow					Viridian
Cadmium Yellow					Hooker's Green
Cadmium Yellow					Emerald Green
Cadmium Yellow					Terra Verte

Appendix

How to set up a Reference Library

Setting up a Colour Code library is vitally important in learning how to mix colours. It not only teaches you as you work, but it provides a permanent record of hundreds, even thousands, of colour mixes which will prove invaluable in the years to come.

The first step is a supply of good quality paper. Although you can make your mixes on anything, including cheap writing paper, the pigments will never behave as they do on proper watercolour paper, and you will lose perhaps 40 per cent of the textures and subtleties of your mixes. Surely a foolish economy. You need not use large sheets – on the contrary, a small pad will do admirably.

Next, sort out the paints which you have and make sure you can include a reasonable selection, based on the subjects you prefer to paint and your individual style of working. A list is provided on page 23 to help you get started. But use this as a guide, not a blueprint, because you should spend some time studying the quality manufacturers' colour charts and discovering for yourself what colours you find particularly useful and exciting.

When you do decide on your purchases, ask for any available information, which should include a colour chart and a note of whether your choices are granular or stains, the level of their transparency and opacity, the ingredients of each formula, and so on. This will prove useful in your quest to learn more about each pigment.

Now you are ready to work. Decide how you want the mixes to work – on the opposite page I have shown just a few of the ways in which you can build up your Colour Codes, or you can simply follow the pattern I have used in Part Three, drawing horizontal bands with the two colours at either end, and then gradually brushing them together, moving quickly from each side until they meet in the centre in an equal mix. Note the names of the colours at the top of the page.

Do this on both top and bottom bands, then repeat the washes on the lower band so that the colour intensifies and the graduated colours in the centre will stand out clearly.

Now to record the more interesting mixes, pick out three colours from the band and repeat these on the right.

Move on to related colour mixes so that you can compare the result – I have only been able to give a selection in this book, but you can concentrate on the range of colours you prefer to work with.

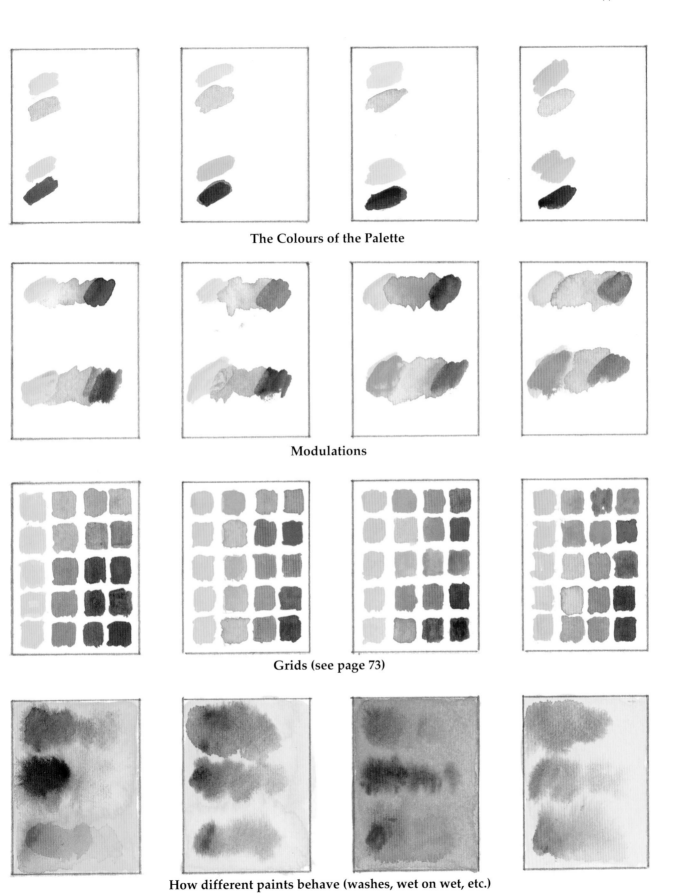

The Colours of the Palette

Modulations

Grids (see page 73)

How different paints behave (washes, wet on wet, etc.)

In the Studio

Once you have made your Colour Codes, don't let them become scattered or torn. You can keep them in a file, but I find that they are most useful tacked up along the wall in my studio.

That way I have a chance to study how the colours work together whenever my work allows a gap of a few minutes, and it is also extremely useful to have them to hand when you are painting. If you know you are looking for a particular subtle blue-green, for example, a quick glance will show you exactly what you want, so that you don't waste time trying out unsuitable mixes on scraps of paper.

Once the basic mixes are established, don't think that is the end. Always keep an eye out for the new colours which the manufacturers bring out every few years, and explore their properties, trying them out for bleeding, lifting and so on. That

The grid printed on page 73 has all you need for measured modulations between two colours, and you can use that for your basic reference library.

This grid (and the Colour Code opposite which uses it) has space for additional modulations when you need even more subtle mixes - flower painting, for example, may require six or seven colours from within the same mix to show the varying hues of a petal or leaf.

way you will get the most out of every purchase and use the potential of each colour to the very fullest degree. And when you are in the middle of working on a painting you will know, without pausing, what colour or mix to choose, and how to let it help you instead of hindering you.

To make your own set of Colour Codes, make a grid for yourself following the example on the left, and then fill it in with the colours you are mixing, as on the right.

Keep a note of which colours you use – the whole idea of the library is, first, to appreciate the huge number of variations possible in the gradations between any two or any three colours, and, second, to have a record of how you achieved those gradations so that you can repeat them whenever the need arises.

Knowing that you can find exactly the colour you want whenever you want it will make working with colour easy and exciting.

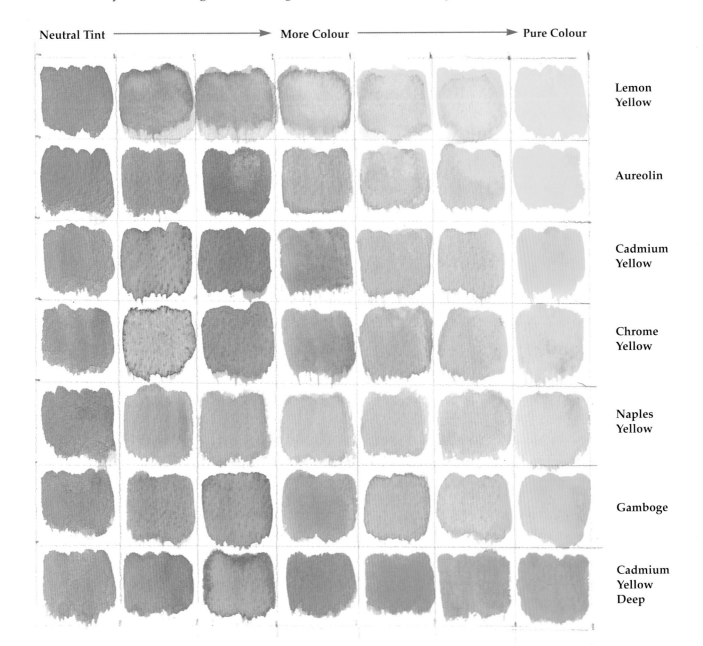

Neutral Tint ⟶ **More Colour** ⟶ **Pure Colour**

Lemon Yellow

Aureolin

Cadmium Yellow

Chrome Yellow

Naples Yellow

Gamboge

Cadmium Yellow Deep

Outdoors

If you intend to go out for the day and plan to do a whole sheaf of paintings, then it is always worthwhile picking up a set of the landscape (or seascape) colour codes and taking them with you. It saves so much time that you will probably come home with four or five extra paintings.

If you do a lot of work outside, then why not make up a mini-set? Choose the colours you need – for me, it is especially the green and blue mixes which can be so difficult to match out of doors. Keep them in a waterproof folder.

Another useful tool is a notebook with the mixes for natural phenomena such as morning skies or stormy seas. If you do paint outdoors for many years, as I have, it is quite difficult to remember details, and the notes come in handy over and over again. I dread the thought of ever losing them.

It may seem like a great deal of trouble, but just look at the two examples given here. The long panel is a typical example of time wasted trying out all kinds of mixes.

The painting is by a student who was trying to mix paints directly onto the paper. Her first wash dried fast, the second wouldn't mix, and the sketch was ruined. With a good set of Colour Codes she could have identified the mix she wanted before starting.

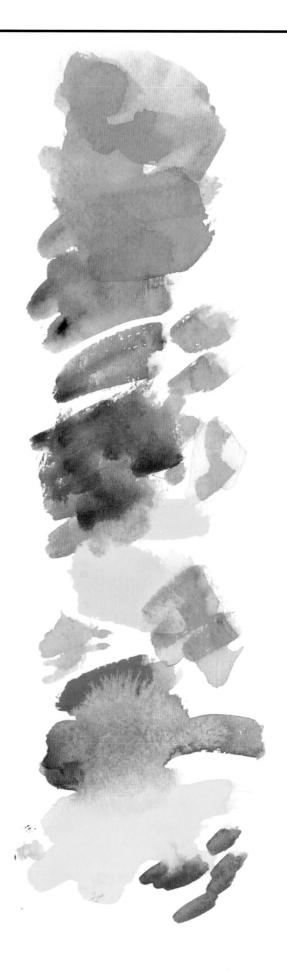

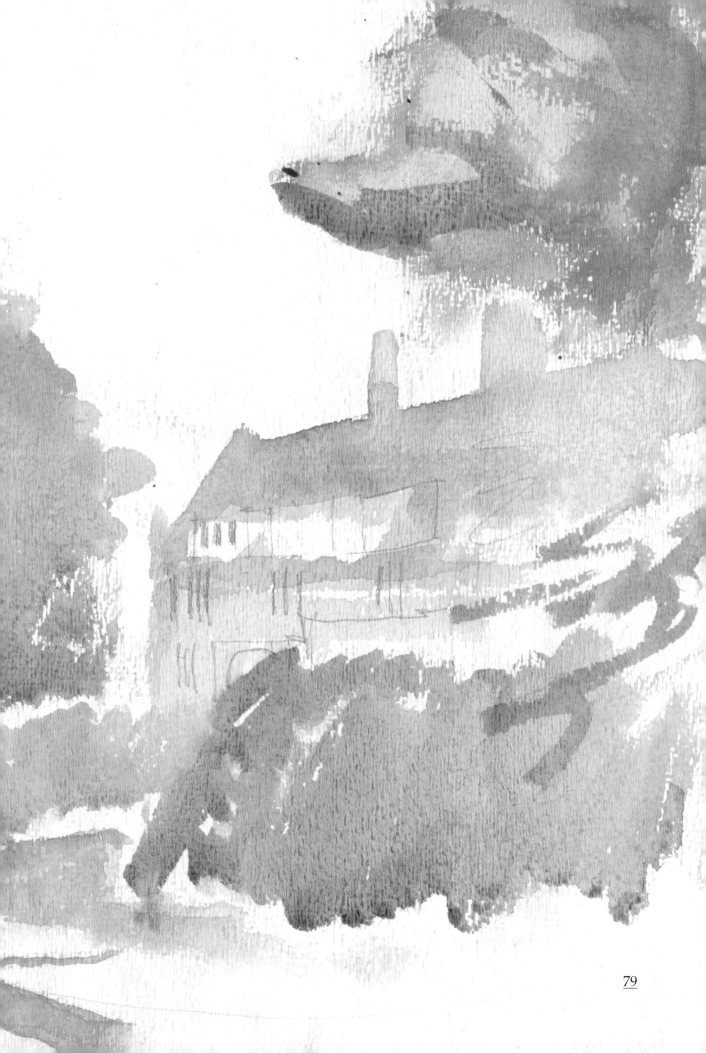

Index of colours